Film Fantasy Scrapbook

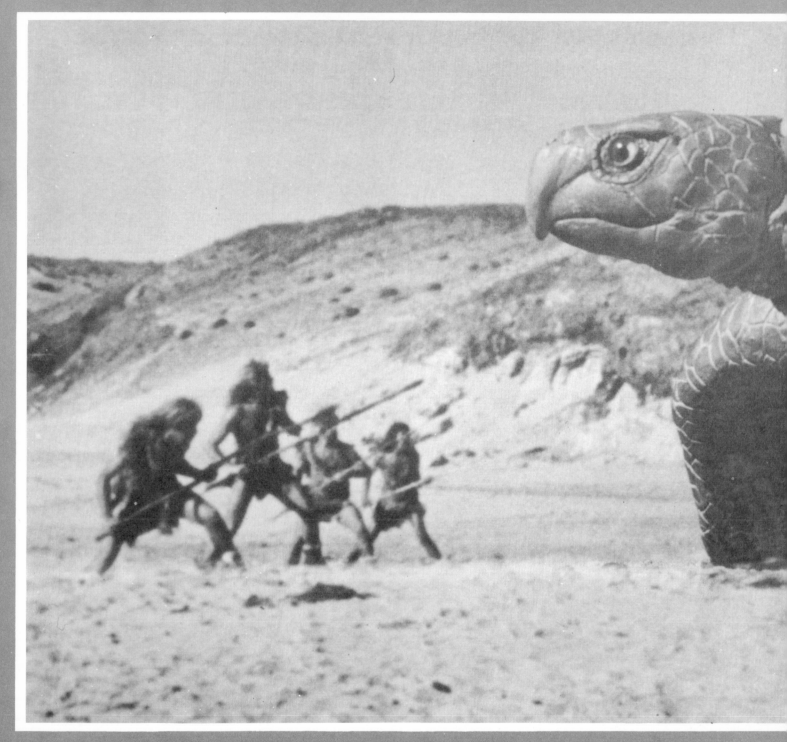

Ray Harryhausen

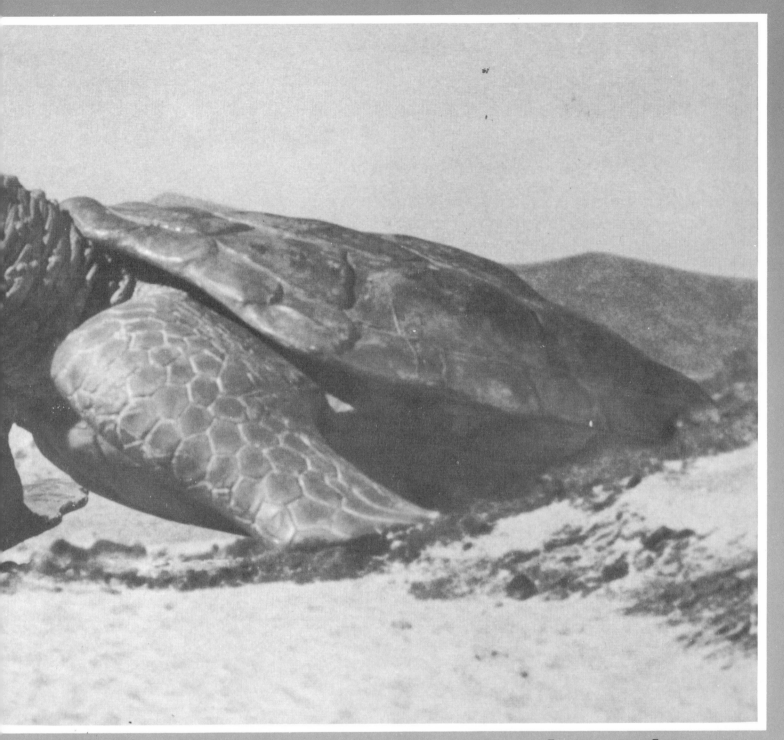

Film Fantasy Scrapbook

South Brunswick and New York: A. S. Barnes and Company
London: The Tantivy Press

A. S. Barnes and Co., Inc.
Cranbury, New Jersey 08512

The Tantivy Press
108 New Bond Street
London W1Y OQX, England

Library of Congress Cataloging in Publication Data

Harryhausen, Ray.
 Film fantasy scrapbook.

 1. Cinematography, Trick. 2. Cinematographers—
Correspondence, reminiscences, etc. I. Title.
TR858.H37 778.5'346 70–169072
ISBN 0–498–01008–2

ISBN: (UK) 90073049 8
Printed in the United States of America

Dedicated to the memory of the late Willis H. O'Brien, without whose inspiration and imagination the field of Fantasy Film making would have sadly suffered.

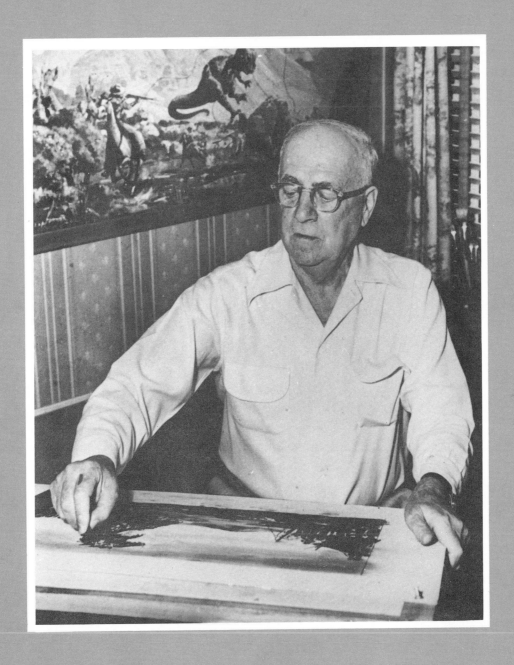

Contents

Acknowledgments

Grateful thanks are due to Forry Ackerman, who, over the years, has added enormously to my collection of stills on *Kong*. More thanks are directed to The British Film Institute, Columbia Pictures, RKO Radio Pictures, Warner Bros., 20th Century-Fox, Hammer Films, Willis O'Brien and Mrs. O'Brien for contributing to my personal accumulation of photographs.

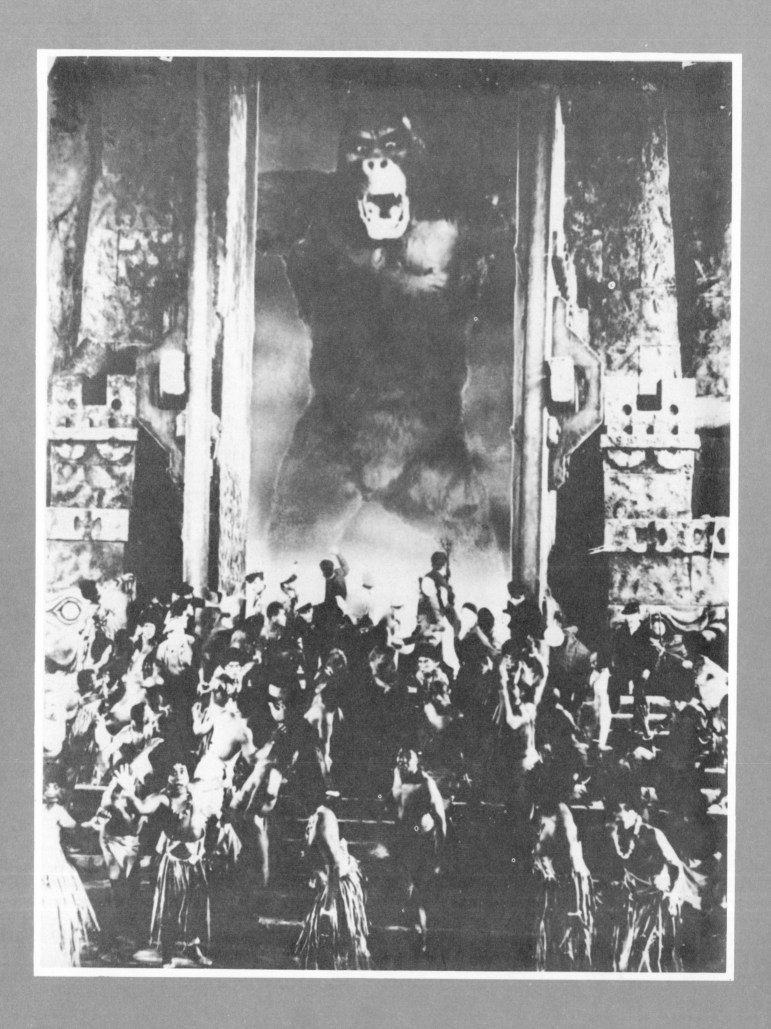

Introduction

How do you write a short Introduction to a long friendship?

How do you put in words the meaning of a relationship that has covered some 34 years now?

It won't be easy, but I must try.

I have known and loved Ray Harryhausen and his work since the night in 1937 when he walked into the Little Brown Room at Clifton's Cafeteria in Los Angeles, for a science-fiction-fan-writer meeting, and showed me his drawings and told me his dreams. In no time at all, I was out visiting his home, prowling his garage, where he kept his dinosaurs, arranging for him to make a life-mask of me, over which he would create a liquid-latex mask of pure green horror with which to terrify my friends at Halloween. If memory serves me, Ray and I went off to an All Hallows Midnight Show at the Paramount Theatre in Los Angeles to see Bob Hope in *The Cat and the Canary*, and in the middle of the show I put on the Harryhausen mask and caused the people in the seats in front of us to jump a foot.

You see, Harryhausen and I, at 17, were like most teenagers. But unlike many, we had large dreams that we intended to fulfill. We used to telephone each other nights and tell the dreams back and forth by the hour: adding, subtracting, shaping and reshaping. His dream was to become the greatest new stop-motion animator in the world, by God. Mine, by the time I was 19, was to work some day with Orson Welles, whose career was beginning to burgeon on the American scene.

Somewhere along through the years, Ray was best man at my wedding.

Somewhere along through the years we realized our dreams. He worked with Mr. O'Brien on *Mighty Joe Young* and soared on his way. I wrote lines for Orson Welles twice: when I did the screenplay of *Moby Dick* for John Huston, and the narration for Nicholas Ray's *King of Kings*.

What you have here in this book is a record of the young and the middle dreams of Ray Harryhausen. Looking through these scores of photographs reminds us once again of the creative powers of single individuals in the world. Not groups, but lonely creative spirits, working long after midnight, change the cinematic and aesthetic machineries of civilization.

Glancing through, I remember those long-ago days in Ray's garage holding his monsters in my hands, and the nights when he came to the house to dance his puppets and marionettes and fill us with delight.

He is "Uncle" Ray at our house. Damned if he isn't Uncle to a whole new generation of film-lovers and fanatics.

This is the proudest Introduction I will ever write in my life. It is written by the boy in me who, at 17, first fell in love with his genius and the extensions of that genius, the delicious monsters that moved in his head and out of his fingers and into our eternal dreams.

Long after we all are gone, his shadow-shows will live through a thousand years in this world.

RAY BRADBURY

Film Fantasy Scrapbook

King Kong

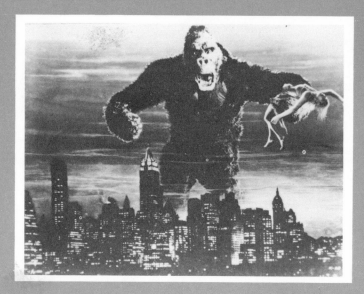

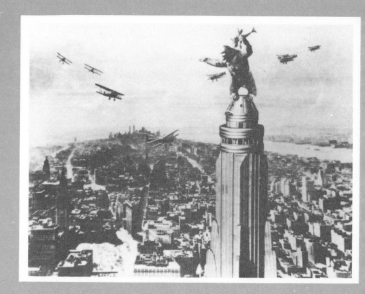

In 1933 a star was born with the original and fascinating name of *King Kong*. Thirty-eight years after its release the film has become a classic in almost every country of the world. Its key advertising campaign was based on the words, "The Picture That Staggers the Imagination." As far as I am concerned there was never a more accurate statement made by a publicist, for this highly original film laid the basic foundation for my choice of career.

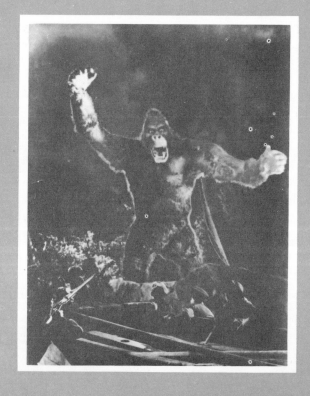

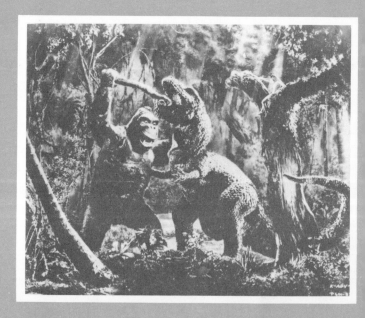

King Kong was an RKO Radio Picture produced and directed by Merian C. Cooper and Ernest B. Schoedsack. The technical creator and animator of *Kong* was Willis H. O'Brien, who seven years before was responsible for the silent version of Conan Doyle's *The Lost World*.

The players in *Kong* were Fay Wray, Robert Armstrong, and Bruce Cabot. Max Steiner's inspired and enthusiastically composed atmospheric musical score was the first truly original film music for a dramatic motion picture to come out of Hollywood for many years. Shortly after, Steiner's score for producer Merian C. Cooper's *She* was almost as masterly.

For those unfamiliar with the technicalities and intricacies of film-making, *Kong* was the first sound feature film to employ the use of miniature rubber models brought to life by a technique called "stop motion" or "stop-action" photography. Like the animated cartoon, it makes use of photographing a series of still pictures, each slightly advanced, which, when projected at 24 frames per second, gives the illusion of movement and life. But unlike the animated cartoon, the miniature sets and flexible animal models can give the added realism of dimension. When properly blended with live action photography it can present a most striking visual effect.

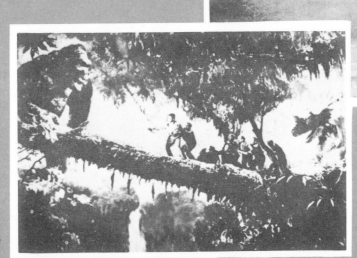

I was 13 at the time of the opening of *Kong*, which took place at the fabulous Grauman's Chinese Theater in Hollywood. The forecourt was decorated with a jungle setting containing live pink flamingos and featuring the full-size moving bust of *Kong* himself. The atmosphere was charged with mystery, spectacle, and anticipation. The marvelous array of stills in front of the cinema, however, could never do justice to the dynamic display of imaginative moving images that were to pass before our eyes on the screen inside. The live prologue of native dancers and acrobats, before the showing of the feature, was the ultimate triumph of the showmanship that unfortunately is so lacking in the film industry today. Again, the superlatives of advertising were bordering on accuracy when they proclaimed *Kong* to be "The Eighth Wonder of the World."

All of this excitement over a film that some might call "trivial entertainment" could suggest that I may be a fanatic about the subject. Perhaps this is true. But I have found over the years that "extravagant enthusiasm" can be half of the battle of turning mere desire into actuality. Many symbols, fantasies, and pseudo-intellectualisms are read into *Kong* today which are heartily denied by its makers. I think it is splendid that it seems to function on several different levels, but even if it did not, this particular picture with its audacious excursion into fantastic adventure contained its own justification.

To appreciate the full value from any film of the past one must try to push himself back in time to the period in which it was made. I'm quite sure that anyone with a grain of respect for technical achievement and artistry in film-making will have to admit that this fascinating picture stands alone as a monument to imagination, showmanship, and pure entertainment.

(Right) *The Lost World,* initiated by Willis O'Brien in 1925, was the first feature film to employ the technique of three dimensional figure animation. His earlier experiments go back to 1914 when he made a number of short subjects with figurines for the old Edison Company.

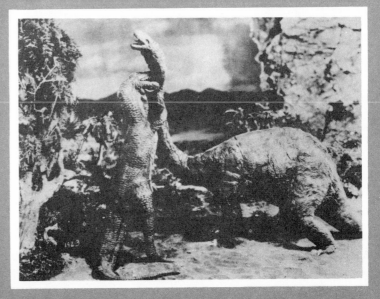

15

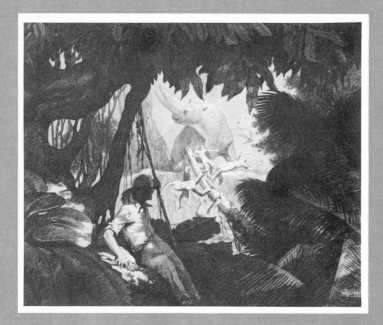

Creation

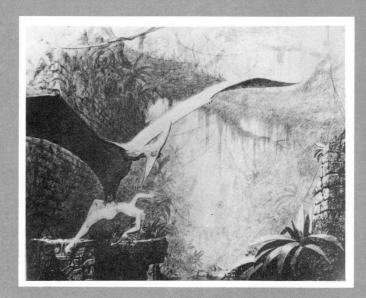

Creation was the forerunner of *King Kong*. Around 1929 Willis O'Brien started story development and production sketches for the proposed production, after an unsuccessful attempt to raise interest and money for a feature film on *Atlantis* and later *Frankenstein*.

About a year's preparation went into *Creation*, which included hundreds of sketches, large and small. Several, of which I have the originals, are reproduced on this page. They are carefully executed renderings by Byron Crabbe and Willis O'Brien. There also exists an album of many photographs of continuity sketches and other drawings for the doomed film (and doomed it seemed to be as the management of RKO was to change once again).

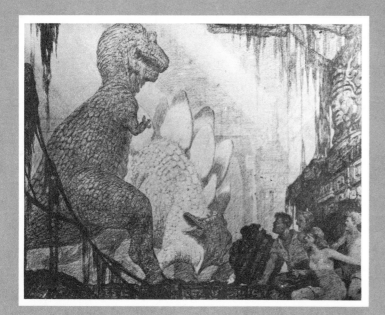

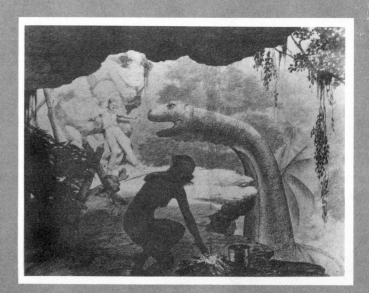

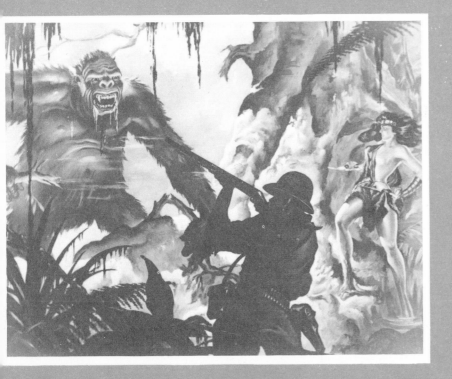

King Kong

On the left is a photograph of the original painting by O'Brien and Crabbe for one of the first concepts of Kong. Below is the large, full-size, mobile bust of Kong that was made for close shots of people struggling in his mouth. It was manipulated manually, as well as by compressed air, by a group of six men. It was this bust that was so dramatically displayed in front of Grauman's Chinese Theater in Hollywood during the opening weeks of *Kong*. It remains a masterpiece of mechanical engineering and artistic creation.

(Left bottom) It is rather interesting to see how certain situations from *Creation* (opposite page, upper left) were transferred to Kong.

Merian C. Cooper was called in at RKO to evaluate all the properties purchased by the new regime. Cooper was highly impressed by O'Brien's many tests and saw the possibilities of using the three dimensional animation medium for a story idea about an outsize gorilla that he had had in the back of his mind for years. The two men joined forces and *Kong* was born. Of course before the new idea could be sold to the front office, a test reel had to be made. The chosen sequence of Kong shaking the man off the log and the allosaurus fight turned out to be so dynamic that Cooper had little trouble in finally selling the idea of a giant prehistoric ape unleashing his fury on modern man. *Kong* was a year in production, costing only about $650,000. It is said that this one production helped to save the studio from bankruptcy during the difficult times of the depression.

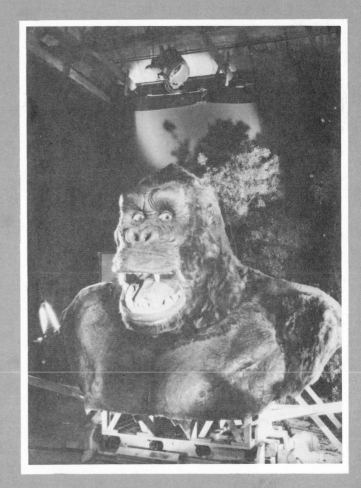

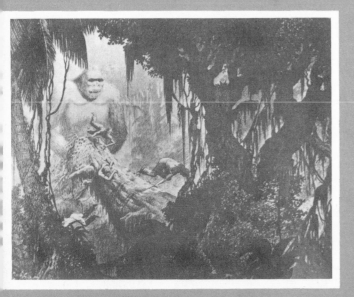

Son of Kong

The *Son of Kong* (1934) was a quick follow-up, obviously trying to cash in on his world-famous father's success. Although certain sequences had some merit the picture as a whole was a great disappointment for the many fans of the mighty *King Kong*. To me, the white "baby" gorilla seemed completely out of character, from his very appearance to the many cartoon-like gestures he exhibited throughout the story. It is a rare sequel indeed that can live up to its original. The *Bride of Frankenstein* was a superb example.

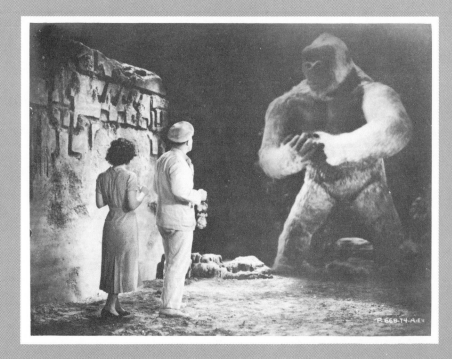

Willis O'Brien and his wonderful technicians were anything but inspired with the *Son of Kong*. It is often said that O'Brien objected strongly to the story and the concept and really had very little to do with the film. When I had the great pleasure of working with him some years later on *Mighty Joe Young*, I remember vividly his reticence in discussing the film at all. I naturally had many questions at the time, but they remained unanswered.

Another Merian C. Cooper production that left a very strong impression on me was *The Last Days of Pompeii* (1935), directed by Ernest B. Schoedsack. Willis O'Brien created a most spectacular earthquake sequence, the like of which has seldom been seen since. The whole concept of the film contained many wonderful things to be admired, and it was certainly Schoedsack's finest job of directing. Basil Rathbone's characterization of Pontius Pilate remains in my mind as outstanding.

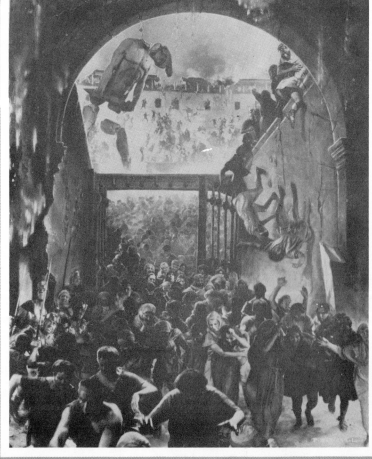

Mighty Joe Young

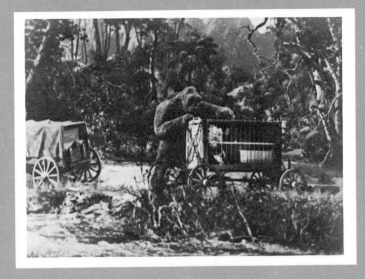

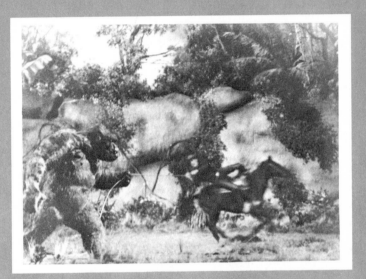

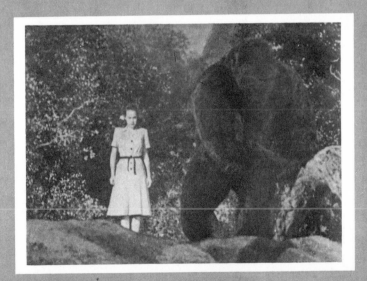

Mighty Joe Young was started around late 1946, when it was then temporarily called *Mr. Joseph Young of Africa*. Merian C. Cooper, Ernest B. Schoedsack, and Willis O'Brien once again teamed to try another ape spectacular. Although it did not equal *Kong* by any means it did win O'Brien the Academy Award for the best Special Effects in 1949.

Before the second World War I had met my mentor, Willis O'Brien, after many years of devoted adoration of his work on *Kong*. The gigantic gorilla had more than stimulated my intense interest in the dimensional animation medium. This finally developed into almost a fetish of experimenting with a 16mm camera. It was only after a number of years of trial and error that I finally had the courage to show O'Brien some samples of my work. His interest and encouragement saw me through many a difficult period. Later, after viewing some of my more refined footage of dinosaurs and fairy tale stories he chose me as his assistant for this new simian epic. It was of course the climax of a long-awaited dream come true. I had a magnificent two-year period of working with O'Brien, covering the long pre-production and design stage up to the end of animation photography. He was so involved in production problems that I ended up animating about 85 per cent of the picture.

In conjunction with O'Brien I designed the first armature of Joe, which was based on the actual skeleton of a real gorilla. Harry Cunningham machined the intricate jointed mechanism with his usual fine precision. Every joint that a real animal would have was duplicated in metal right down to the little finger. Later, Marcel Delgado, who had worked with O'Brien on *Kong* and *The Lost World*, built up the body muscles with foam rubber, dental dam, and cotton. Marcel is an expert with this technique. Eventually, four large apes about 12 inches high were made and two smaller ones. The hair was carefully fashioned by taxidermist George Lofgren, who had devised a new process of rubberizing animal fur.

I had my favorite model of the four. It was the only figure I really felt at home with and which I could successfully manipulate into the many complicated poses I visualized in my mind. It is really quite fascinating how one can become attached to a mass of metal and rubber. It may be that it was all in my own mind but there was something about this one model that seemed to reflect the very essence of gorillahood. As incredible as this may seem to the layman, this can make all the difference in maintaining character values and their corresponding harmonious action patterns.

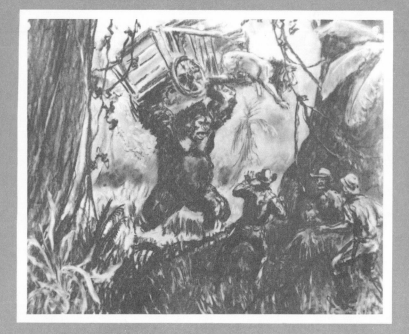

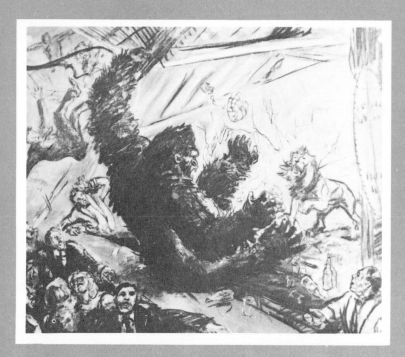

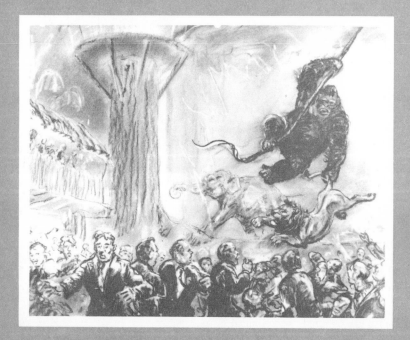

The drawings included on these two pages are pre-production sketches from *Mighty Joe Young* by the late Willis O'Brien. I include these to illustrate to what great lengths film designers must go in search of interesting and unusual "gags," or, more appropriately, situations. In a film such as this, it is not always the writer or the director who comes up with all of the ideas. The three drawings on this page were charcoal sketches measuring just a little over two feet wide. The other five pictures on the next page were executed in wash, water color, and charcoal pencil. They were drawn on a much smaller scale. It is essential that the illustrations be made rather quickly as perhaps a hundred or more will have to be produced. Often the drawings have to be discarded because of story changes based on new ideas, some of which are derived from these very same sketches.

Drawings of this nature can serve a three-fold purpose. (1) As a stimulation in story discussions for script development. (2) Aid in selling the idea to the "front office," which includes raising finances before a final screenplay is produced. (3) To give everyone connected with the picture a uniform sense of the direction that the film is striving for visually. There are some conventional productions that are sketched out in full with every change of camera angle plotted on the drawing board before actual production begins.

The visualizations shown here are only the pre-production sketches, some being discards. After the script is finalized a complete new series of drawings has to be made, which are called continuity sketches. They will represent the camera angle as well as illustrate scene continuity of the sequence. Apropos a "special effect" picture such as *Mighty Joe Young*, the continuity sketch will give everyone on the film the necessary details of what is involved in the many composite shots. Take, for example, a scene that has to be shot as "rear projection." The sketch will show clearly what part of the composition must be photographed first. It will also help to form a closer understanding between the director and the special effects creator. Invention and creation on the set can be terribly costly with today's high production prices, which make it doubly important to solve as many problems as possible beforehand.

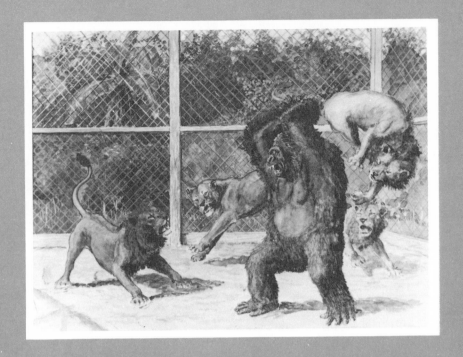

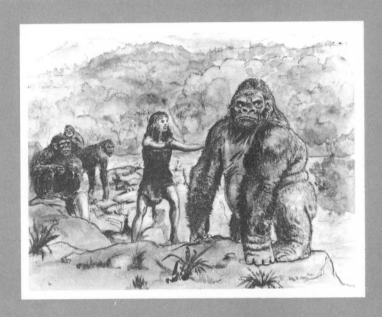

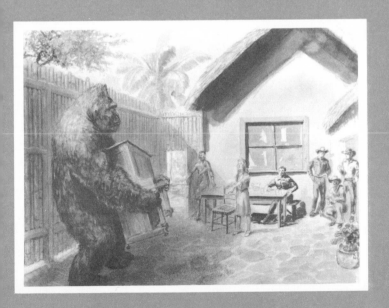

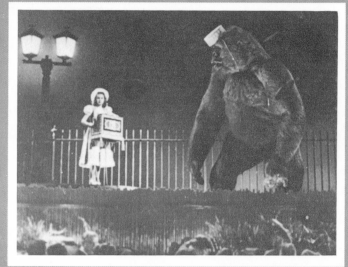

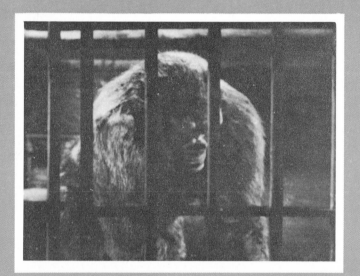

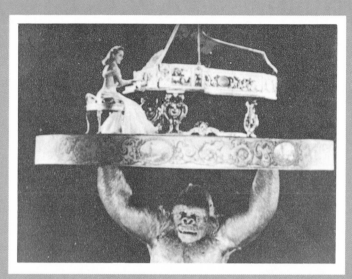

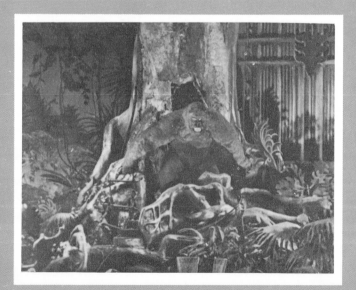

The first scenes of animation I did for *Mighty Joe Young* comprised the basement sequence where Joe has been put back into his cage. It was a very slow-paced scene and required almost microscopic movements of the figure. Shooting one frame of motion picture film at a time can become very tedious when the character has to move slowly. It took about three days to record 15 seconds of action.

I was really anxious to get to the "drunk" sequence. Three men in the story try to get Joe intoxicated with whisky. This offered some wonderful possibilities for interesting patterns of movement.

During pre-production we sent a man to the Chicago Zoo to photograph, in motion, one of the few large gorillas in captivity. The film was most useful for studying the pace and stride of his walk as well as detailed idiosyncrasies.

22

The Valley of the Mist

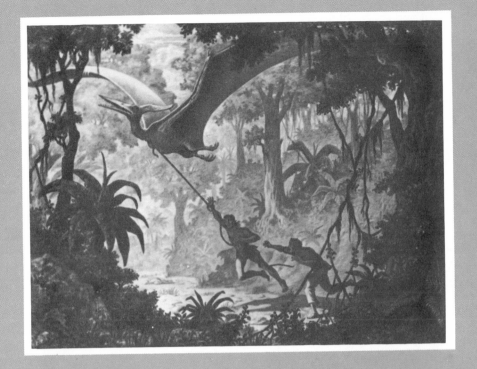

Mighty Joe Young was quite favorably received by the reviewers but never really gained the public's admiration as did its predecessor, *King Kong*. I personally felt it was the "tongue-in-cheek" approach that destroyed the full box-office potential. But I could be wrong. Willis O'Brien was soon working on another story line in which producer Jesse L. Lasky Sr. became very interested. O'Brien spent about six months producing a fully illustrated story outline, which was later bound in cowhide—a truly impressive presentation for his unusual Western theme. I joined forces with him and rendered several large drawings for the project, some of which are reproduced here. The picture was to be released by Paramount under the title of *The Valley of the Mist*. Willis and his wife Darlyne had developed and expanded the idea together. During its early history they had called it *Emilio and Guloso* and later changed it to *El Toro Estrella*. When Lasky took the project over he decided *The Valley of the Mist* would be a better marquee title. Jesse Lasky Jr. wrote the final screenplay and William Lasky was to be Associate Producer, but unfortunately it was called off before it reached the production stage. The option for the story rights reverted to O'Brien after a period of time, whereupon he sold the idea to another company. A new screen treatment was developed but the project was soon abandoned once again. As far as I know it was never produced, at least in the way O'Brien originally wrote it. There have been tales that the basic story was filmed by still another company—minus the prehistoric animals. The mystery of the final destination of this particular project deepens even more with its later involvement in a lawsuit as well as having the honor of winning an Academy Award for the best Original Screenplay. The award was later withdrawn as the writer of the screenplay could not be located.

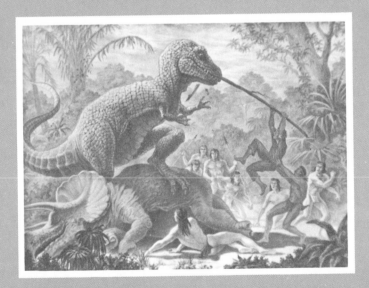

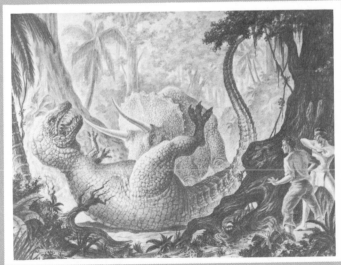

In retrospect, my early experiments were, to say the least, over ambitious. The above drawing was one of my first sketches, probably about 1939, of a sequence in a proposed film concerning a creature from Jupiter.

(Upper right) Shows the completed miniature set and animated model. Some footage in black-and-white was photographed of the animal but it was all in the nature of disconnected experiments. The experience at that time of actually designing and building the flexible model was invaluable.

(Right and below) Early sketches for a sequence in my proposed epic called *Evolution*.

(Lower right) Sketch for a short 16mm animated film on the subject of David and Goliath that was never filmed.

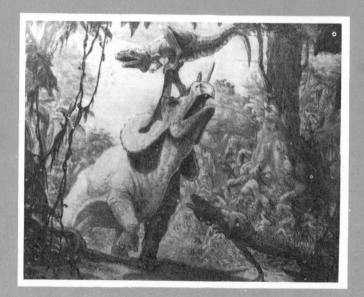

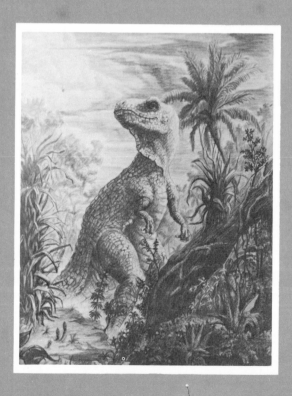

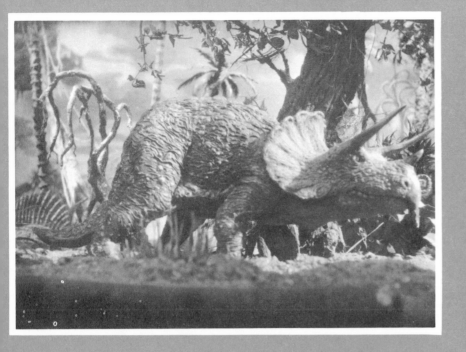

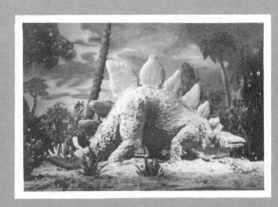

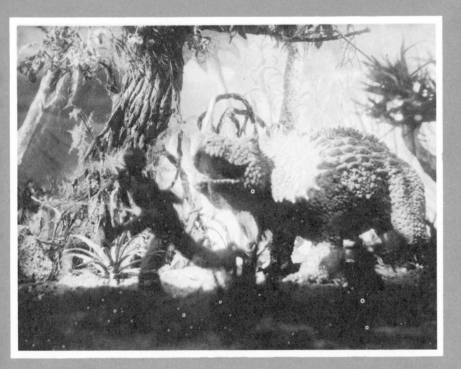

(Above right) Stegosaurus and a cave bear were my first animated models. They date back to about early 1938. The skeleton of the bear was constructed of wood and fully jointed. I later found steel armatures to be much more durable. My mother's fur coat provided the exterior.

(Left) The Triceratops and Agathaumas were my first fully jointed metal "skeletal-build-up" rubber figures. The exterior flexible material was carefully shaped over the steel armatures, which had been padded with cotton and rubber muscles.

(Left) Another angle of the creature from Jupiter. Although my pet project *Evolution* was abandoned as well as the science fiction subjects, the photographed footage I had made served as a good demonstration reel in gaining my first commercial position with George Pal when he first started his world-famous *Puppetoons* for Paramount Pictures. I enjoyed enormously working with George Pal's short subjects for two years but my real desire was to be involved with a serious feature fantasy film. It wasn't until after three years in the Army Signal Corps that I was finally to realize my dream of *Mighty Joe Young*.

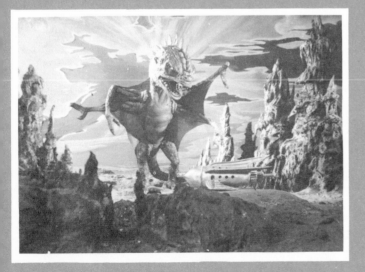

Mother Goose Stories

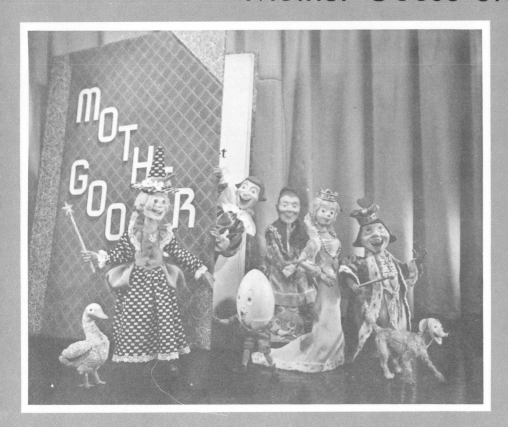

It was about the middle of 1945 when I finally got out of the army. For many years it had been a great desire of mine to visit Yucatan and I found this time to be the perfect opportunity to circle back to California via Florida, Cuba, and Mexico. My mustering-out pay just about covered all the expenses.

Arriving home in Los Angeles, I found an unusual amount of outdated Kodachrome. I tried desperately to think up a subject on which I could use it before it became too old. *Mother Goose Stories* was the result. The four subjects I chose to animate in the puppet medium was *Little Miss Muffet, Old Mother Hubbard, The Queen of Hearts,* and *Humpty Dumpty.* They were originally to be separate subjects lasting two and a half to three minutes. After completion, I decided to join them together with a prologue and epilogue featuring the character of Mother Goose. A soundtrack was added with synchronized music cues. This was the first in a series of five ten-minute Fairy Tales that found ready market in schools, churches, clubs, and libraries all over the United States. They have now been distributed world wide and some of them have been translated into other languages.

(Below) Old Mother Hubbard and her precocious dog.

(Left bottom) Humpty Dumpty and one of the "King's Men."

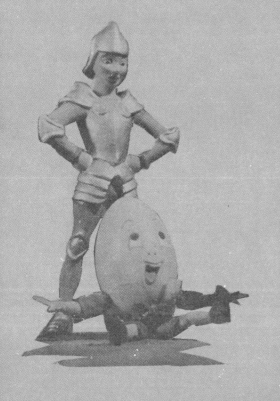

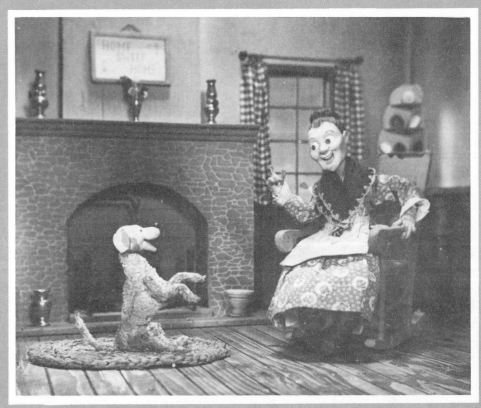

Little Red Riding Hood

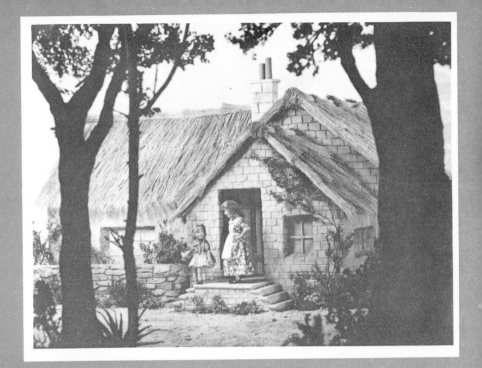

Between further experiments with more dinosaur footage for *Evolution,* I managed to make a second short subject, *Little Red Riding Hood.* It was photographed with three-dimensional puppets in stop-motion photography similar to the *Mother Goose Stories.* This time one story was used lasting the full ten minutes. Once again I did the photography, construction, design of puppets, and scenery as well as general production. My mother dressed the models and my father, in his spare time, gave me great help in making props and armatures.

A very dear friend of mine, Charlott Knight, a talented writer, actress, and director who was in New York, kindly offered to write the narrative, which was all done by post. Later the music and voice was added to the finished film. It joined *Mother Goose* along with three other stories in a world release by Bailey-Film Associates.

(Lower right) One of my early adventures into TV commercials featuring a character "Kenny Key." It was made for a local housing project. The subject was three minutes long but I fear very unsuccessful.

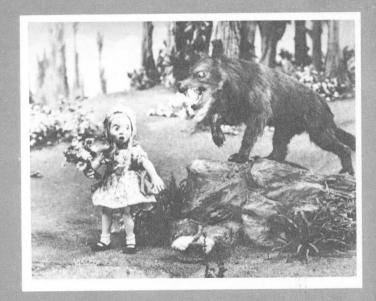

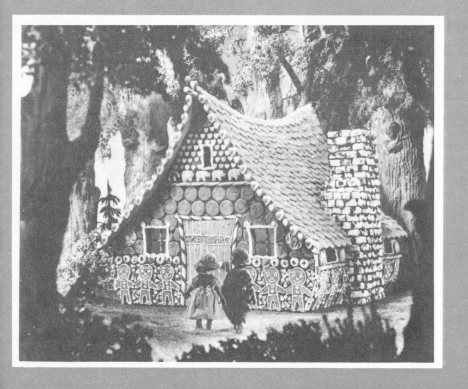

Hansel and Gretel

The success of *Mother Goose Stories* and *Little Red Riding Hood* encouraged me to go ahead with two other projects, *Hansel and Gretel* and *Rapunzel*. Both were made almost simultaneously, as I had in the back of my mind the rather extravagant thought of making 15 or 20 ten-minute subjects for television.

I approached *Hansel and Gretel* in the same way as *Red Riding Hood*—with simple narrative and a good full-music background. Lip-synchronization was avoided because of the additional time it would involve in production. The technique I developed for *Mother Goose*, of dissolving in eight frames one extreme expression into the other for change of facial movements, was once more employed.

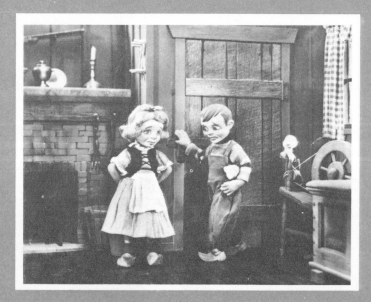

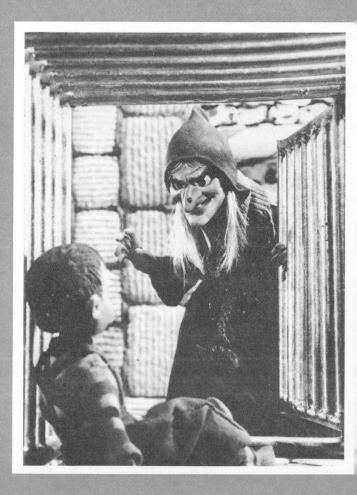

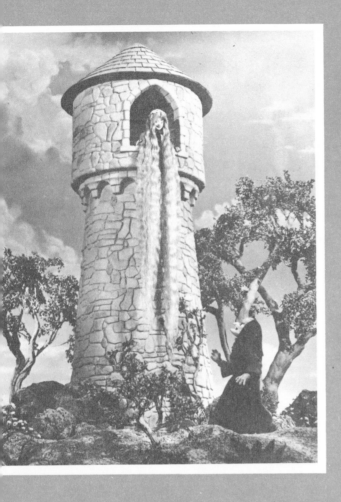

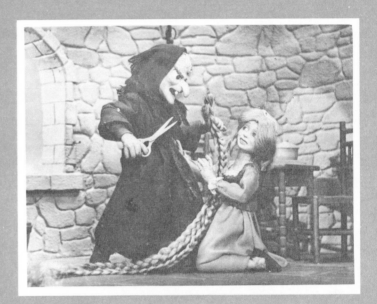

The story of Rapunzel was really a bit too mature for the age group of the other films, but what intrigued me about the subject was the idea of the tower and Rapunzel's long golden hair being used as a ladder. Like so many Fairy Stories, when one reads about them, the absurdities seem to fade away into the imagination. But acting out the action in the plot can present many practical problems.

The original *Red Riding Hood* story, for example, is quite gruesome and rather lascivious by today's interpretations. Actually to see someone chop open the wolf's stomach and find Grandmother and Red Riding Hood inside alive, could more than earn an "X" certificate. It then becomes quite necessary to modify the story in the name of "good taste."

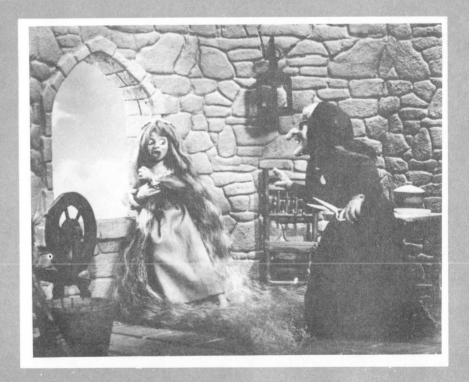

The Story
of King Midas

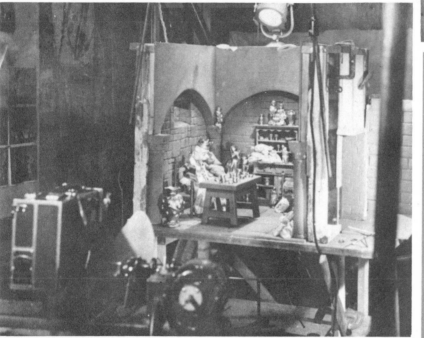

King Midas turned out to be the last of the series of five Fairy Stories. It was more elaborate than the other four but seemed to lack the charm of the early *Mother Goose* film.

By this time I began to realize that to do 15 or 20 ten-minute subjects would take from up to three to four years. I was not prepared to devote this much time to this subject matter. It was then that I decided to make one more to complete an even six. *The Tortoise and the Hare* was started but never finished. Somewhere, among the vast quantity of stored footage, lies about 200 feet of what promised to be the best of the six.

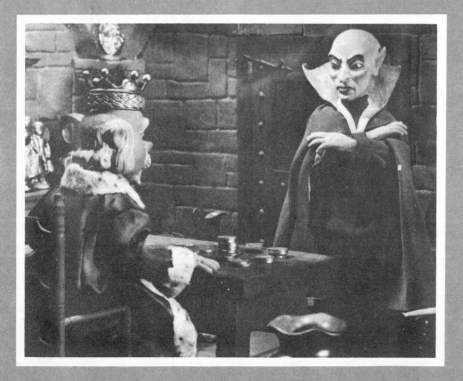

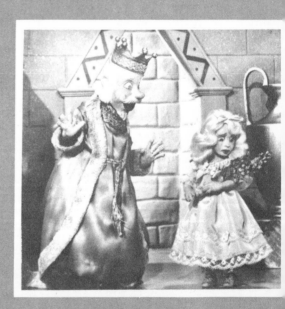

(Above) From an early film concerning "Bridge Building" that was made about 1940. It lasted five minutes and dealt with the problems of having to bridge a gorge with a prefabricated assembly.

(Upper right) Sculptured figures that I modeled for the cover of *Yank Magazine,* which was done from a design of Phil Eastman's.

(Below) Two figures of an Army character called Snafu. The picture in lower left also appeared on the cover of *Yank Magazine.*

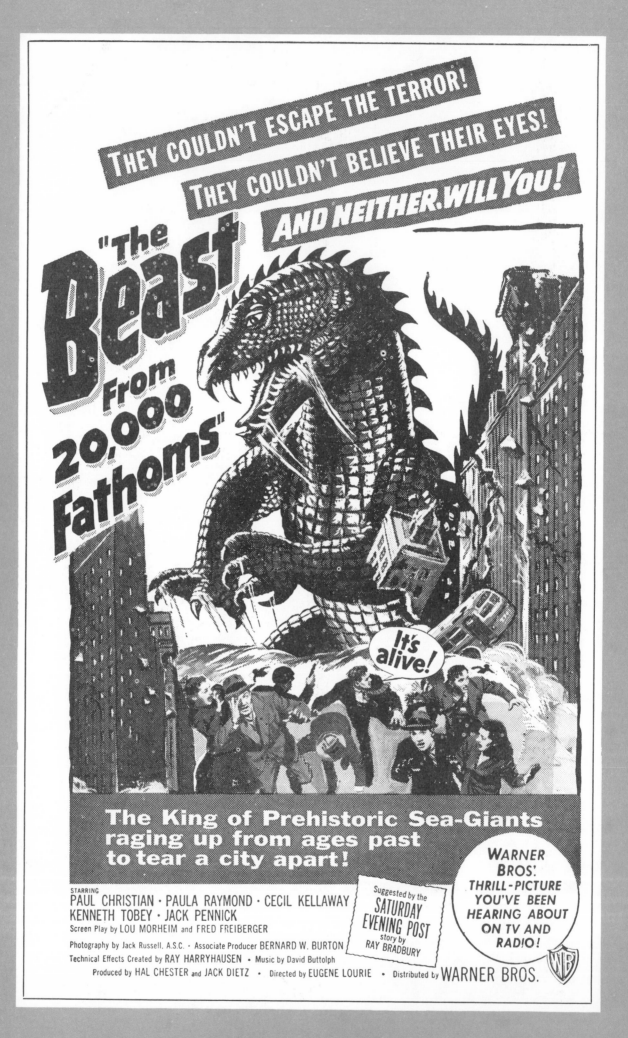

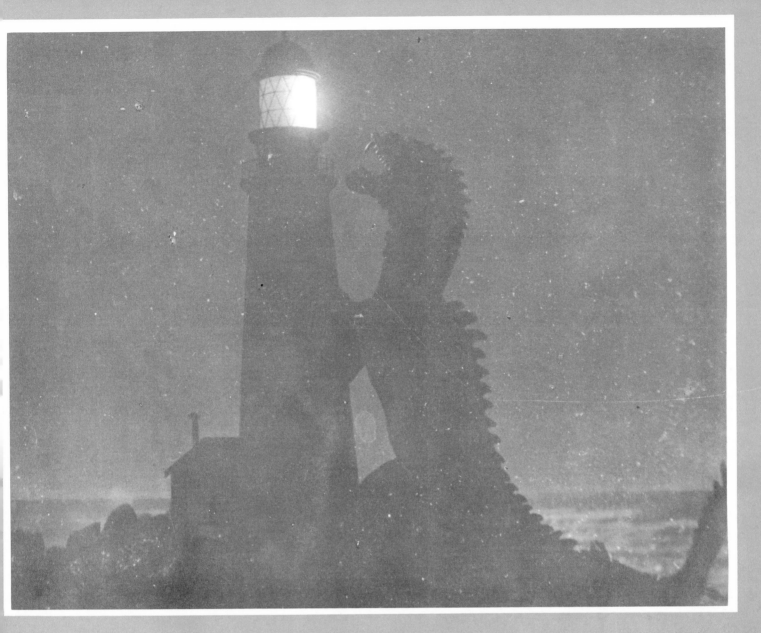

The Beast
from 20,000 Fathoms

The first rough draft screenplay under the title *The Monster from Beneath the Sea* was devised when Ray Bradbury's *The Beast from 20,000 Fathoms* came out in the *Saturday Evening Post*. The producers were highly impressed by the illustrations and Ray's idea of a lighthouse being attacked by a sea monster. They soon made arrangements to buy the story rights. The *Saturday Evening Post* story was hardly long enough for a feature film in itself. In the completed film, only the title was used and a brief sequence of the creature destroying the lighthouse. It was for *The Beast from 20,000 Fathoms* that I first developed a simplified technique of combining animated models with live backgrounds. The film had a very low budget and did not warrant the complicated and now rather expensive technique of using glass paintings combined with miniature rear projection in the manner of *Mighty Joe Young*. Many scenes in this film used a "front-projection" technique, which, although not executed with the use of a 45-degree 60-40 glass and beaded screen, was nevertheless "front-projection." Since the development of the special reflective beaded screen, front-projection, on a larger scale, has suddenly become widely used in recent years. I found it an interesting challenge to try to find new ways and less expensive ways of achieving a spectacular pictorial effect. The production's final cost was around $200,000, which even in 1952 was an exploitation film made for very little money. At the time of its release there was great competition with three dimensional photography as well as wide screen and CinemaScope. Warner Bros. bought it up, and released it in "glorious Sepia Tone," making a very big profit as it turned out to be the surprise money grosser of the year.

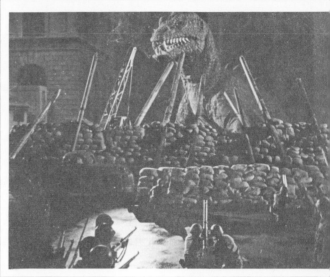

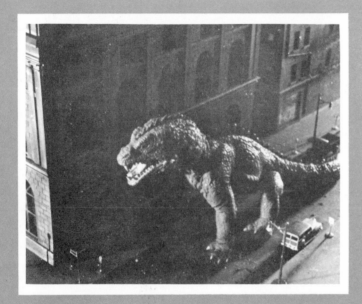

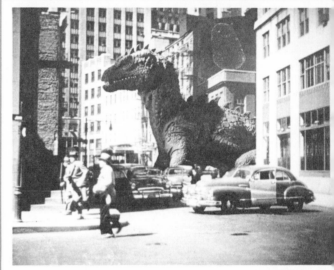

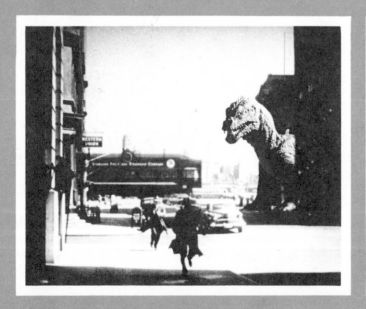

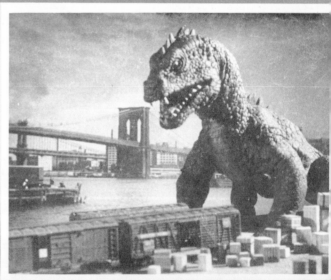

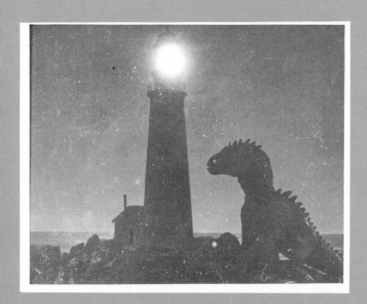
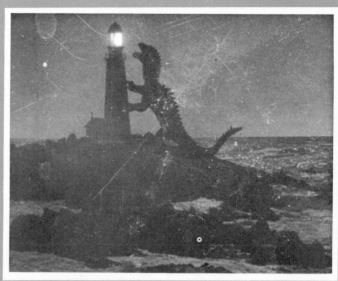
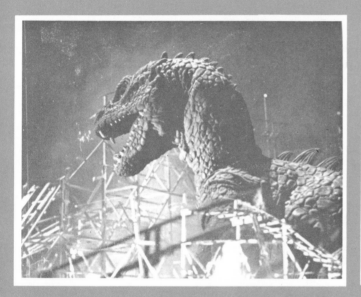
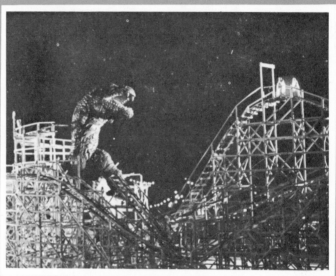
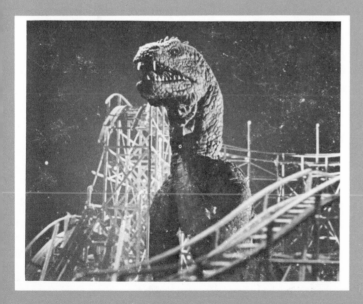
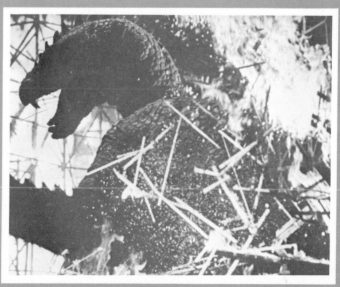

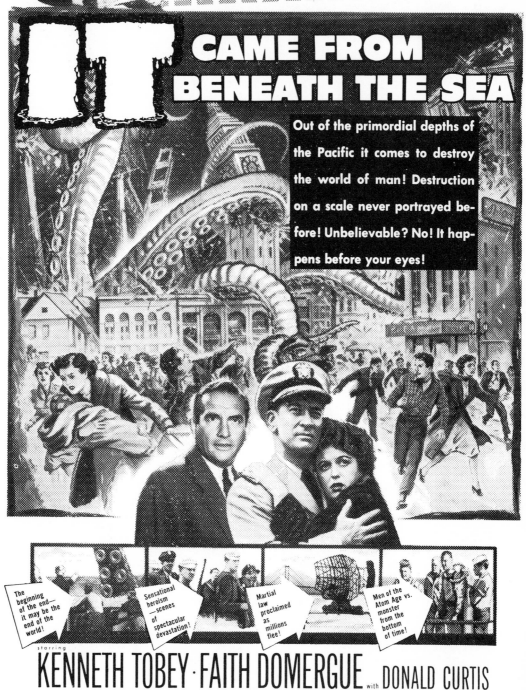

IT CAME FROM BENEATH THE SEA

Out of the primordial depths of the Pacific it comes to destroy the world of man! Destruction on a scale never portrayed before! Unbelievable? No! It happens before your eyes!

The beginning of the end— it may be the end of the world!

Sensational heroism —scenes of spectacular devastation!

Martial law proclaimed as millions flee!

Men of the Atom Age vs. monster from the bottom of time!

starring
KENNETH TOBEY · FAITH DOMERGUE with DONALD CURTIS

Screen Play by GEORGE WORTHING YATES and HAL SMITH · Technical Effects Created by RAY HARRYHAUSEN · Executive Producer-SAM KATZMAN
Produced by CHARLES H. SCHNEER · Directed by ROBERT GORDON · A COLUMBIA PICTURE

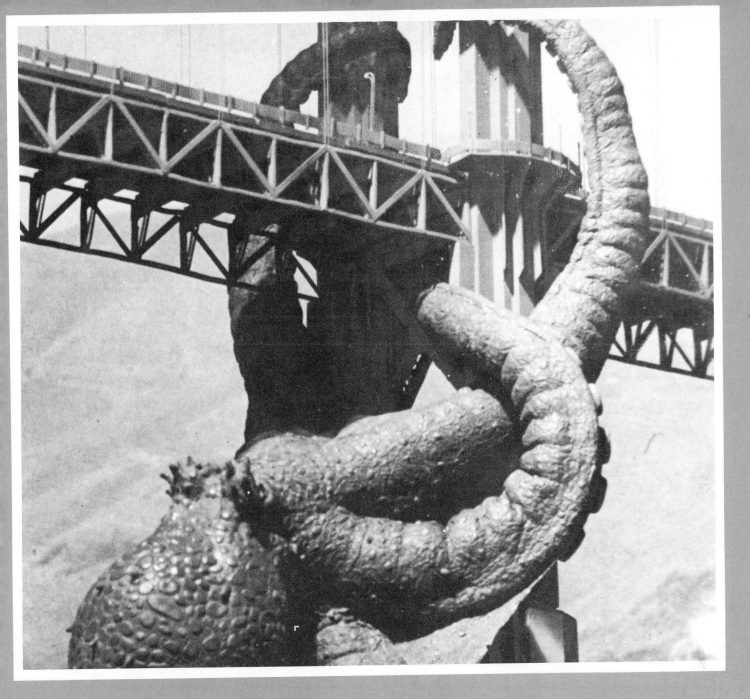

It Came from Beneath The Sea

It Came from Beneath the Sea was started in 1953. I was just about to resume photography on another 16mm, ten-minute project called *The Tortoise and the Hare* when I received a call from an old army friend who wanted me to meet a young producer interested in making a film about a giant octopus which was so enormous that it was able to pull down San Francisco's Golden Gate Bridge.

The challenge presented to my imagination, concerning the numerous technical problems which I could envision, haunted me several days before I agreed to the meeting. Besides, it was my prime wish at the time to try to finish the sixth of the Story Book series. I really did not want to become involved in another lengthy feature until its completion. I cannot now remember exactly what it was that made me change my mind, but I suddenly decided I would look into the matter after all. This was my first meeting with Charles Schneer.

My decision at least to investigate the proposed project was indeed fortunate, as it turned out to be the prelude of what later became a very happy association which has lasted for over 17 years.

For those of you who have seen the picture, you may or may not have noticed that the octopus only had six tentacles. By necessity, we had to work on a rather tight budget and no matter how ridiculous it may sound, two tentacles less to build and animate during the long process of stop-motion photography, among other compromises, did save quite a bit of time. And in Hollywood, time is money. I sometime wonder if the budget had been cut anymore if we might not have ended up with an undulating tripod for the star villain of the picture.

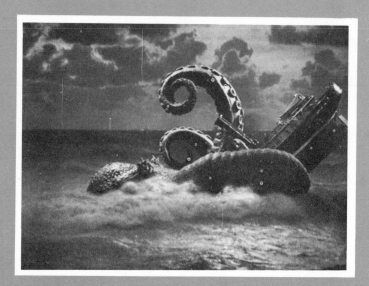

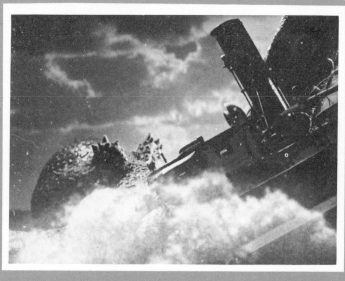

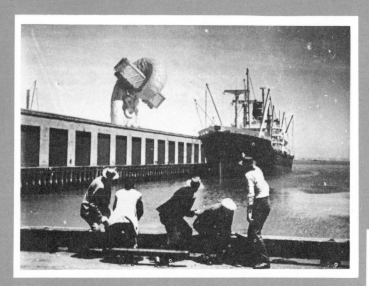

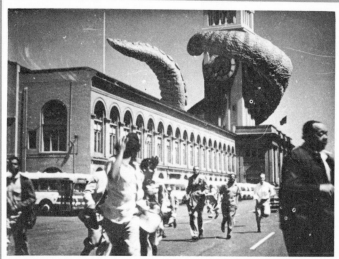

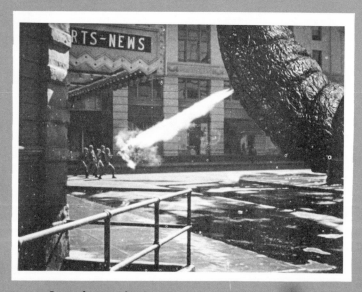

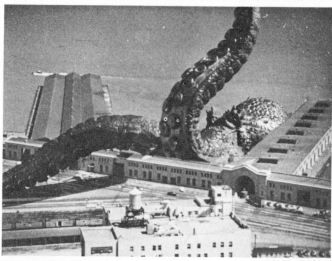

In order to obtain permission and cooperation to photograph the various landmarks in San Francisco it was necessary to present the script to the "City Fathers" for approval. We were astonished to be confronted with a big "No" on the matter of the Golden Gate Bridge. We supposed they felt that any suggestion of destruction on film, even in a fantasy, might undermine the public's confidence in the soundness of its structure. We had of course gone too far into production to be defeated by this decision. Because it was imperative to have real shots of the bridge we were forced to be resourceful and to resort to other means. Much stock footage and newsreel material was also used to great advantage and economy.

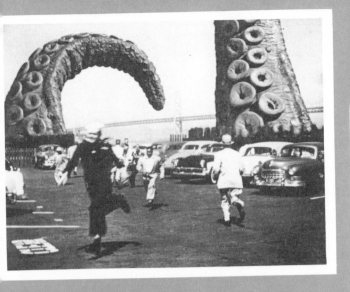

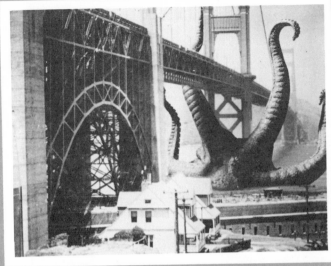

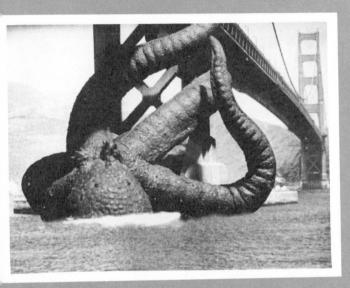

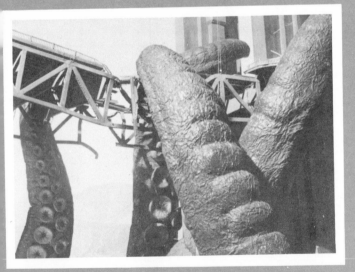

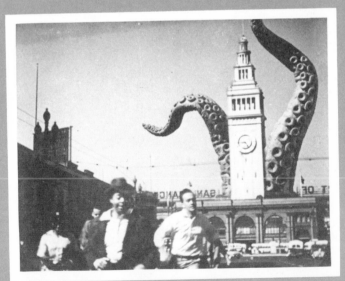

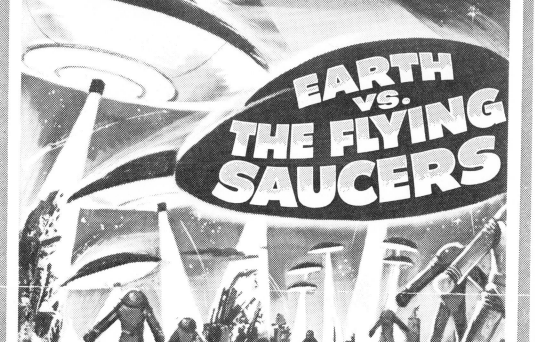

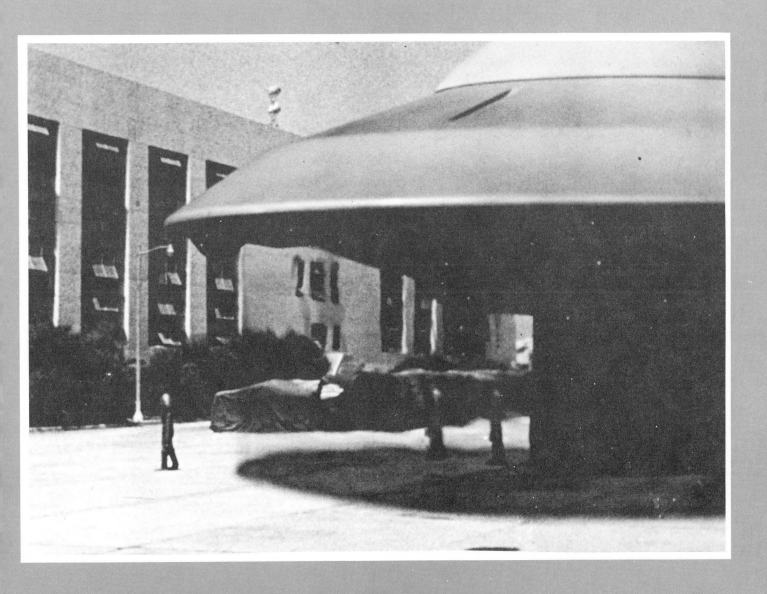

The Earth vs. the Flying Saucers

The flying saucer reports were predominant in the news and Charles Schneer wanted to develop a film about an invasion of our planet by saucers from outer space. This project gradually developed into *The Earth Versus the Flying Saucers*, in which we succeeded in totally destroying Washington, D.C.—through the use of special effects, of course.

I was rather engrossed with the premise of this film. Indulging in the luxury of hindsight, I think some of the picture's latent dramatic and visual values would have been brought out more had there been time to refine the script as well as present a more imaginative musical score.

A prime fascination to me was the challenge of seeing just how interesting one could make an inanimate object such as a rounded metal spaceship. Although the variations were limited for stop-motion they did have great potentials for doing something a little different than the other "saucer pictures" of the time.

One of the most difficult tasks of this particular project lay in the animation of the destruction of the falling buildings. They had to be photographed in the process of disintegration by a death ray, frame by frame—each falling brick being suspended by invisible wires. It would have been far more effective to photograph them in high-speed photography but the cost of this process was prohibitive.

Flying saucers have always been a fascination to me, which made the film doubly interesting to work on. A great deal of research was necessary to keep the whole idea as credible as possible and within the scope of reported sightings. Of course imagination had to play its part in the script as well. This examination of facts brought me into contact with various groups and individuals who claimed to have had actual contact with these beings, supposedly from outer space. I still have an open mind about the subject and am eagerly waiting for more concrete evidence of their existence.

The drawing at the left is one of my earlier conceptions of the first landing of the great spaceship. Below are photographs taken from the actual frame of film showing how it eventually appeared on a deserted beach. The saucer itself was only 12 inches across but it was magnified to give the awesome impression of size.

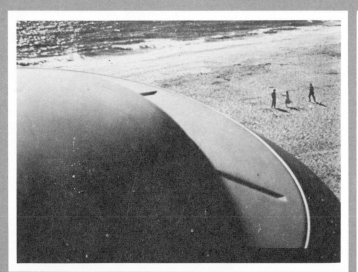

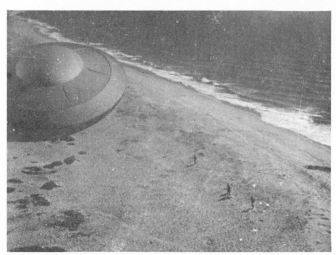

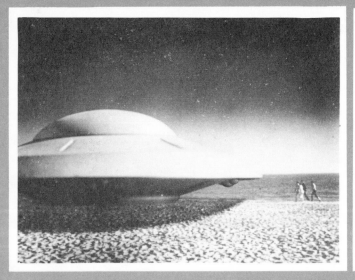

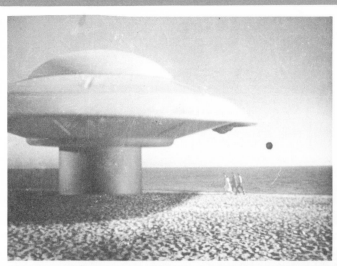

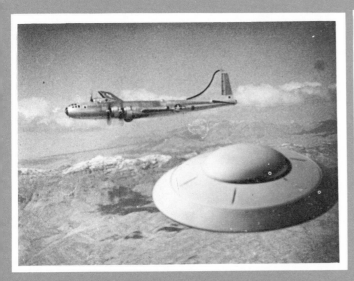 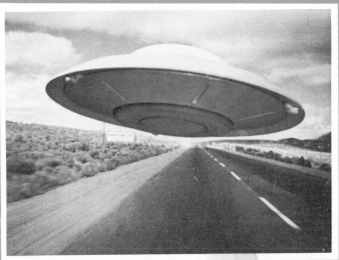

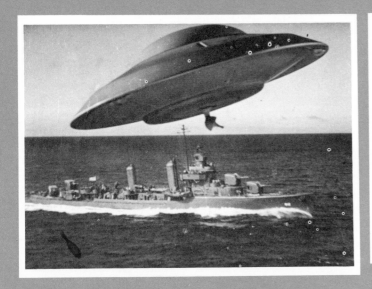 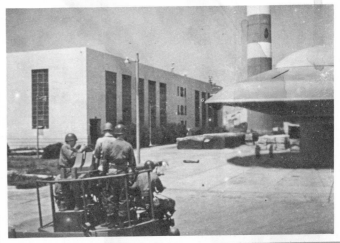

 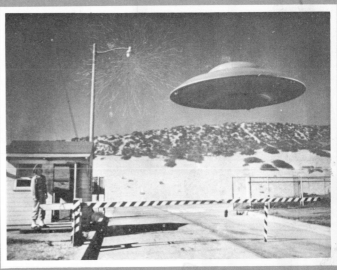

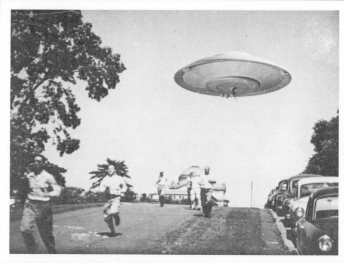

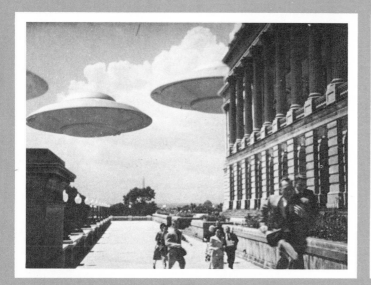

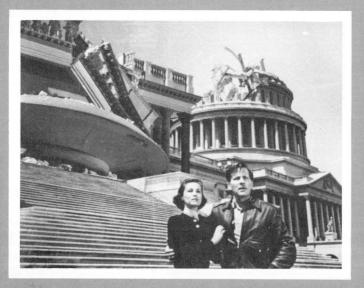

(Left) This scene was actually shot at the Capitol Building in Washington, D.C., and through a combination of an inlay of miniature and front projection the final destruction effect was achieved.

The Playa Del Rey Sewage Disposal Plant was used for one location. Its structure acted as the rocket base in the film. The many weird noises of the underground motors of the plant became the basis of the saucer sounds.

The Animal World

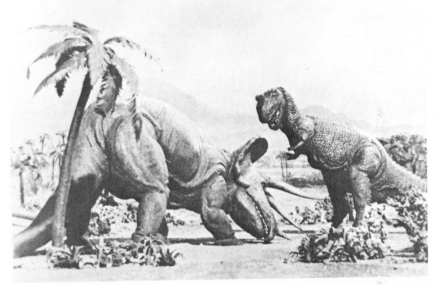

The Animal World was an interesting film to work on but a relatively short one for me compared to most of my other projects. In all, we spent about eight weeks on the actual animation, which only included the dinosaur sequence. We did not have any sequences involving double printing or miniature rear projection, thus enabling us to use two cameras on each set-up. This of course gave us a large amount of footage for cutting. Willis O'Brien designed the animals and set-ups and I was commissioned to do the animation.

This semi-documentary film was made up of some remarkable footage of animal life supplied by "nature cameramen" from all over the world. It was indeed a masterful compilation of interesting visuals and facts. All of us connected with the production were very pleased to hear that the most favorable comments seemed to be about the grandeur of the prehistoric sequence.

The dinosaurs in this particular production were all cast from molds. It is a faster method of covering the models than the "build-up" technique, which calls for the rather slow process of building up each muscle over the metal armature and then covering it with a properly textured skin. The "build-up" technique can give a more realistic effect.

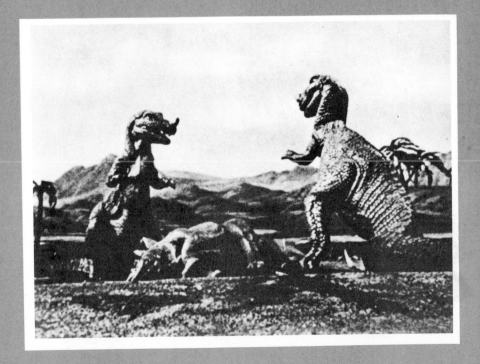

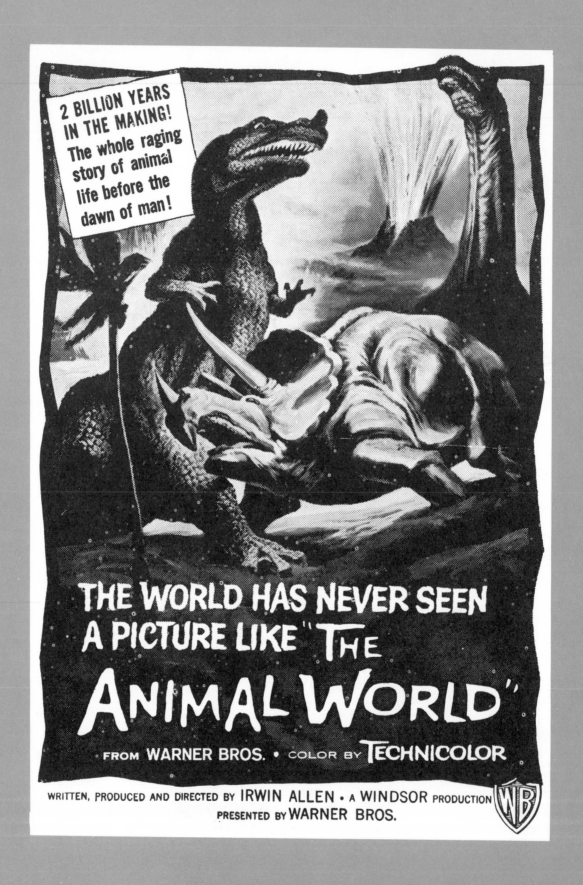

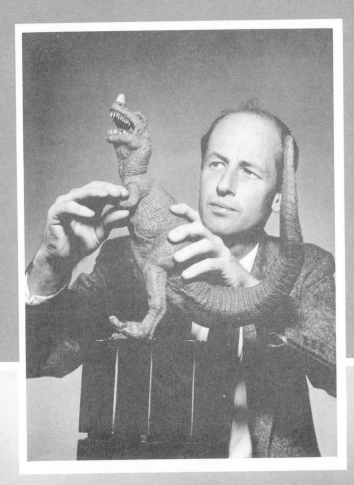

(Below) In the small photograph of the two animals fighting, large mechanically operated models were constructed for the very close shots. Personally I feel a more realistic effect can be obtained by using a good detailed stop-action model. With rare exception, most figures I have seen operated by wires or mechanics always seem to have limitations and repetitions.

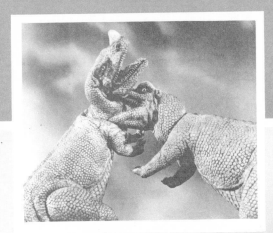

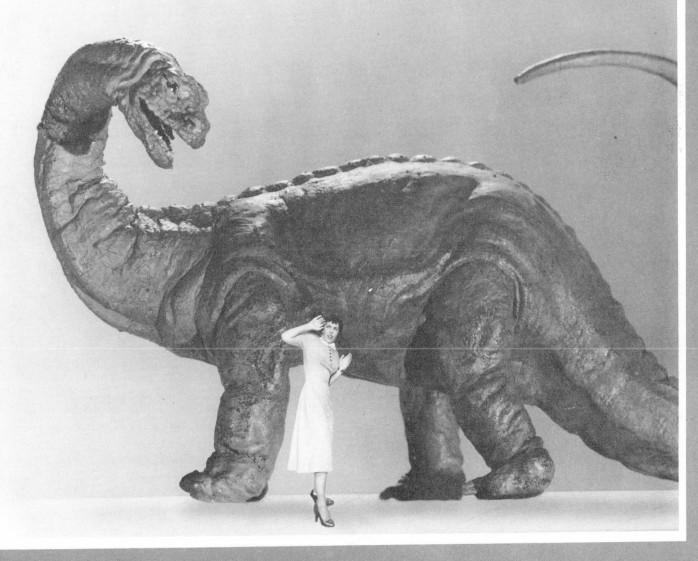

47

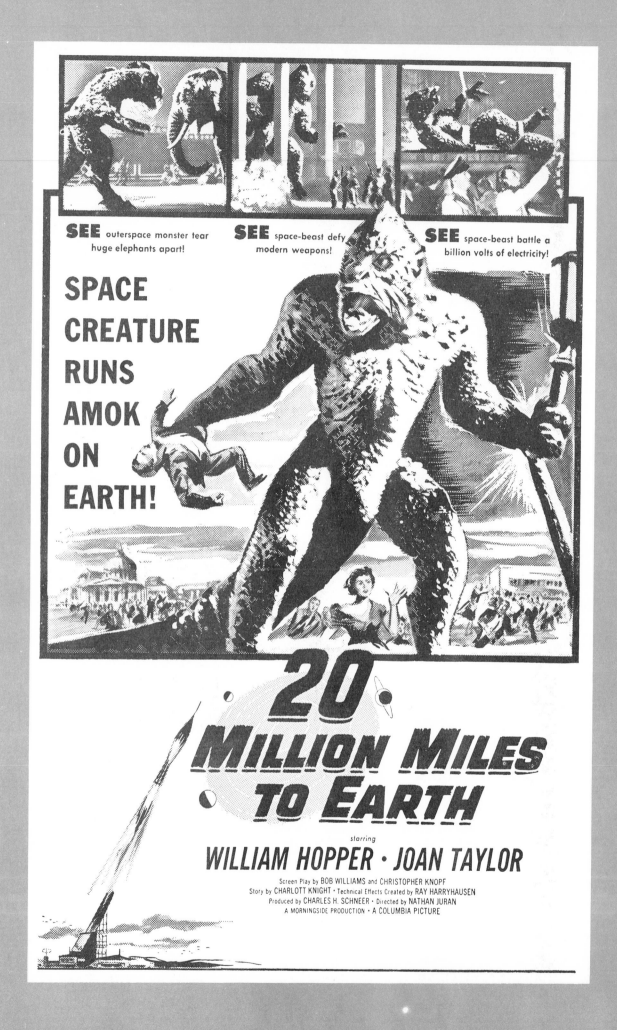

20 Million Miles
to Earth

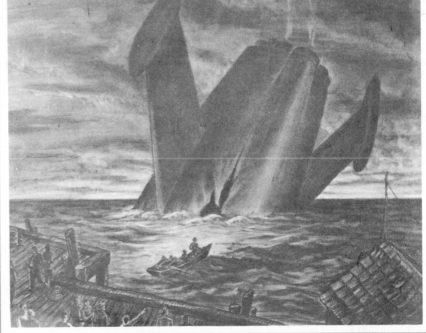

Around 1952 I felt myself getting restless and had a longing to go to Europe. At the time I did not have the money for a proper vacation so thought I would try to dream up a story idea for a film that required European locations. The results were *The Elementals,* which was about giant humanoid bat-creatures invading Paris, and *The Giant Ymir,* a yarn concerning an American rocket ship that returned to earth from a secret visit to the planet Venus bringing back a specimen of life from that world. Our atmosphere changed its rate of growth, causing it to double its size over night. Rome was a romantic spot and I rather fancied having the Ymir in the final reel leave a mass of new ruins among the old. At that period of film-making it was important to include the ultimate in mass devastation if one even hoped to sell an idea. Both stories were highly illustrated, which made them a much more attractive package.

The Elementals was bought by Jack Dietz, the co-producer of *The Beast from Twenty Thousand Fathoms,* and promptly turned into a screenplay. *The Giant Ymir* was filed away under the heading, "story possibilities." After months of waiting around for a script and a "go ahead," I finally realized that *The Elementals* would never see the light of day as far as production was concerned.

Some years later I was going through my files and discovered *The Giant Ymir.* Its many faults stood out like the boot of Italy on a map. It was then that I turned it over to a writer friend of mine, Charlott Knight, with whom I had worked many years before on the Fairy Tales. She read it, rather liked its basic idea, and suggested a number of plot changes that I knew were necessary. While Charlott was involved in re-working the whole story, I sketched feverishly, preparing new illustrations that could be included in the final presentation. Several film companies looked at it but turned it down as they thought it far too complicated and costly. Also I don't think they were thoroughly convinced that I could do what I said I could do with the visual effects. Once again it was filed, but only for a short while as Charles Schneer became interested in it and we figured ways and means to bring it in on a reasonable budget. Its final title was *Twenty Million Miles to Earth.* Rome was kept as a location, and thus I got my wish to go abroad even though it was for just a short period. The picture was released in 1957 and was quite successful.

(Right) One of the many sketches I made for *The Elementals.* It was also necessary for me to photograph a short test reel, in color, to demonstrate the practicality of the idea.

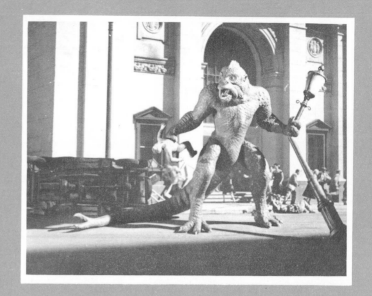

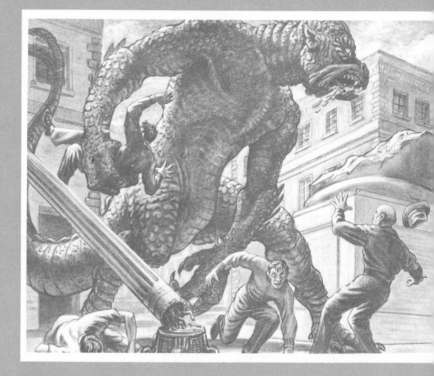

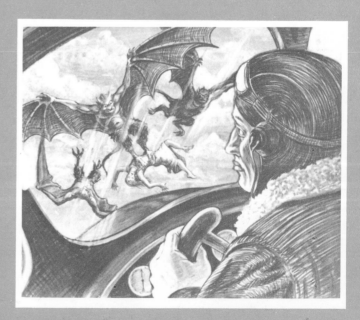

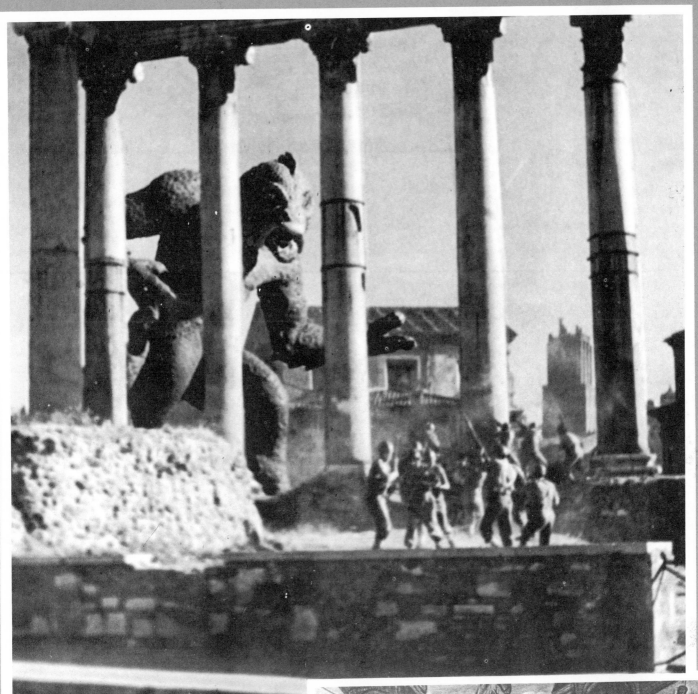

Rome offered enormous possibilities for new and unusual backgrounds for *Twenty Million Miles to Earth*. I spent two weeks searching out suitable locations, which included the streets of the city and the Colosseum itself. The Roman Forum, Temple of Saturn (above), Tiber River, and all of the other monuments gave our modest film an aura of grandeur. It was for this production that we first met our director, Nathan Juran, who later worked with us on several others.

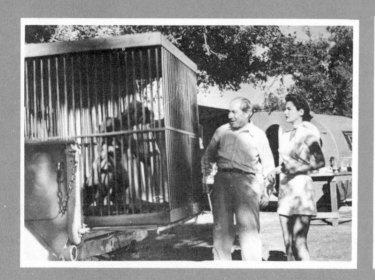

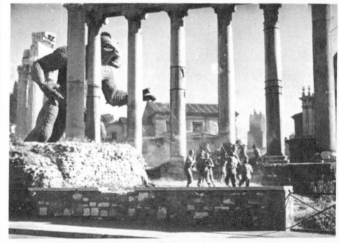

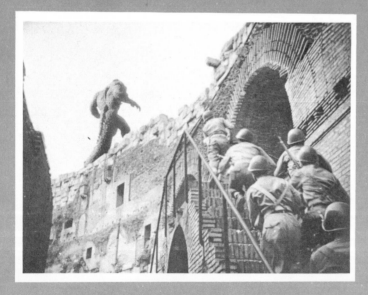

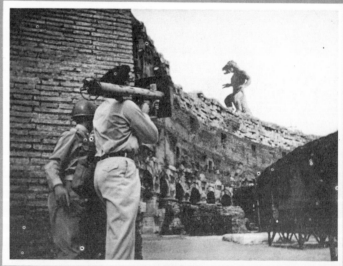

52

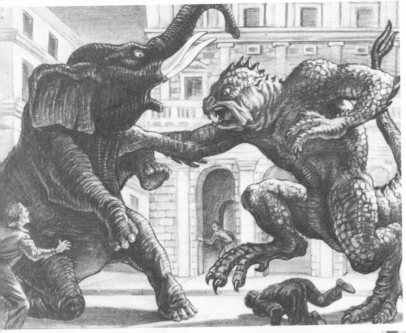

Even the Borghese Gallery could not escape being a background for the fierce battle between the Ymir and an elephant.

The preliminary sketch (left) stimulated many ideas for this sequence.

(Below) Several scenes were done with a real elephant, substituting an animated model where necessary.

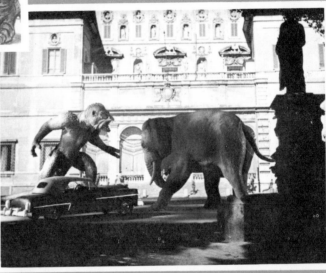

(Below) The Colosseum seemed a fitting end for our friend the Ymir. The structure's height and circular design lent itself to some interesting compositions. I always find it rather upsetting to have to kill off the "villain." Dramaturgy demands that the "villain" should die in the most dramatic way possible. The top of the Colosseum offered this opportunity. Another "must," in my opinion, is that the "villain" should die with a touch of pathos. I am told that we have achieved this in most of our films.

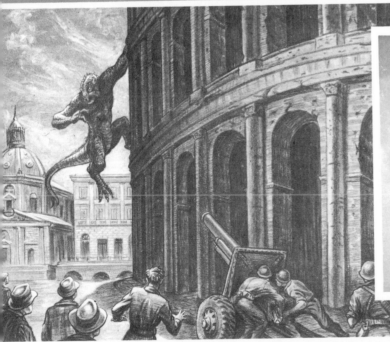

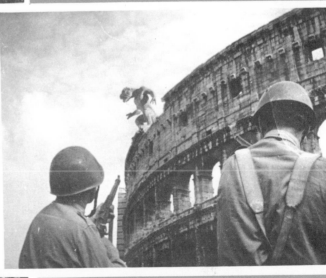

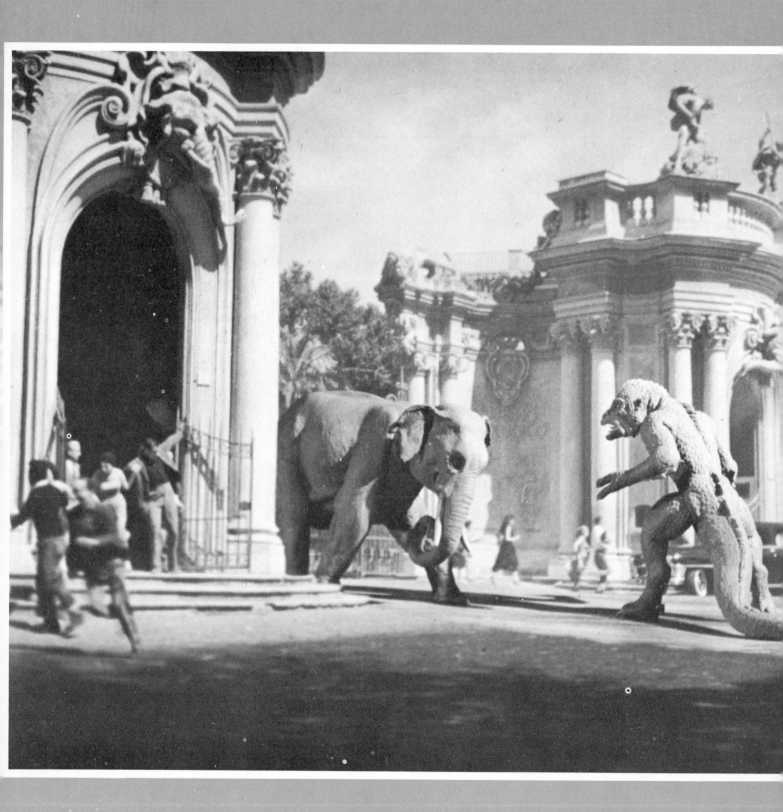

The 7th Voyage of Sinbad

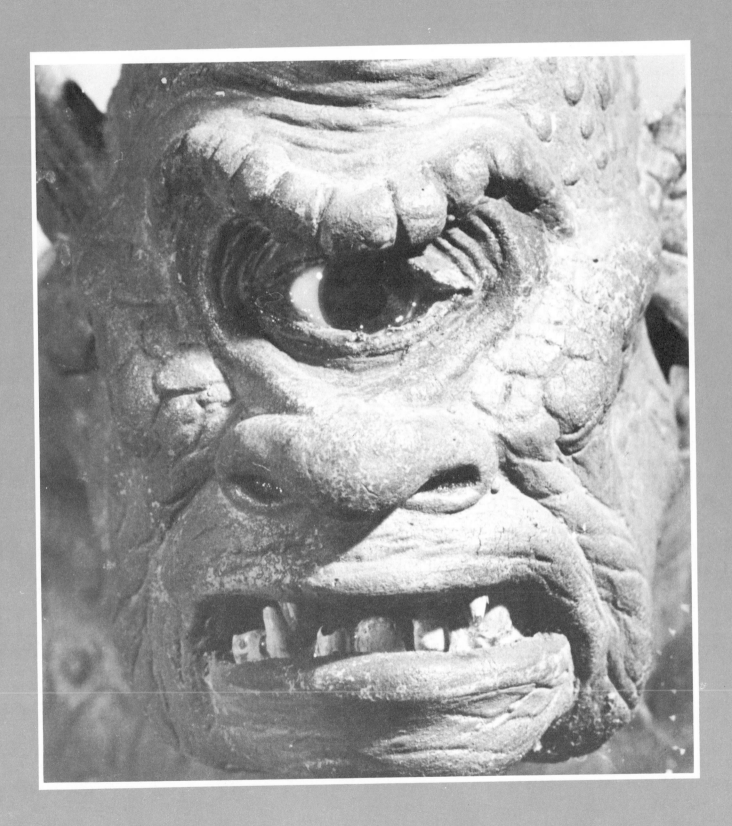

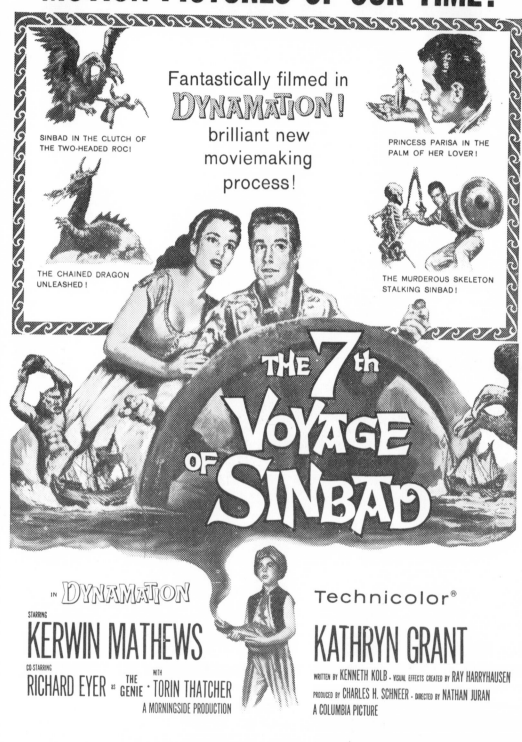

The 7th Voyage of Sinbad turned out to be the "sleeper" of 1958. Its success made it doubly exciting to me when I recall how hard it was to get it on the screen. In my spare time, over a period of about two years, I had prepared a series of large renderings showing the highlights of what I thought would make a unique and interesting approach to the Arabian Nights' Tales for the cinema screen. The number seven has had a magical connotation throughout history and I felt it would make a rather good title for the proposed project.

In the past, the approach to this subject matter had always been to emphasize the "girly" element latent in its motif. Other attempts have turned out to be simply "cops and robbers" in baggy pants. It was almost heartbreaking, after working so long on the idea, to learn that a "new" film was about to be made with a "tongue-in-cheek" approach combined with the "girly" element. A noted "strip artist" was chosen for the lead. When this "new" film failed to do business at the box-office everyone in charge of new projects in the studios seemed to be firmly convinced that Arabian Fairy Tales, particularly with the good name of Sinbad in it, were poison at the box-office. After four or five discouraging attempts at presenting a rough outline of my approach and my drawings to various producers and studios, I finally filed it, like several other ideas, under "story possibilities."

Some months later it was quite by chance that I mentioned Sinbad to producer Charles Schneer during a discussion about a future project. To date our films together were of a contemporary and topical nature. His interest prompted me to rummage in my files once again. After seeing some of the large sketches his enthusiasm doubled and we almost immediately embarked on it for our next film. Charles commissioned Kenneth Kolb to develop a more coherent story line as well as to write the final shooting script. In their original form, Sinbad's adventures are somewhat disconnected, particularly for screen material.

(Upper left) An example of split-screen photography. The tiny figure of Miss Grant was achieved by placing her on top of rather high rock and photographing her at a distance. This shot was later combined with a large close shot of Kerwin Mathews in the foreground.

(Left) The "over-size prop" is still another method of reducing the size of a normal human actor. The giant pillow was later matted into a shot of a section of a real bed.

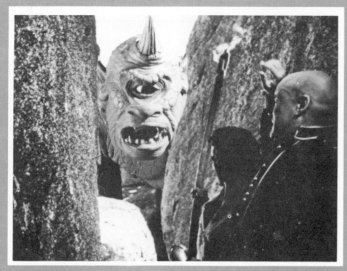

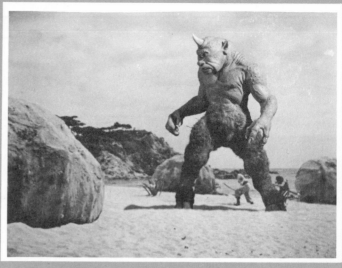

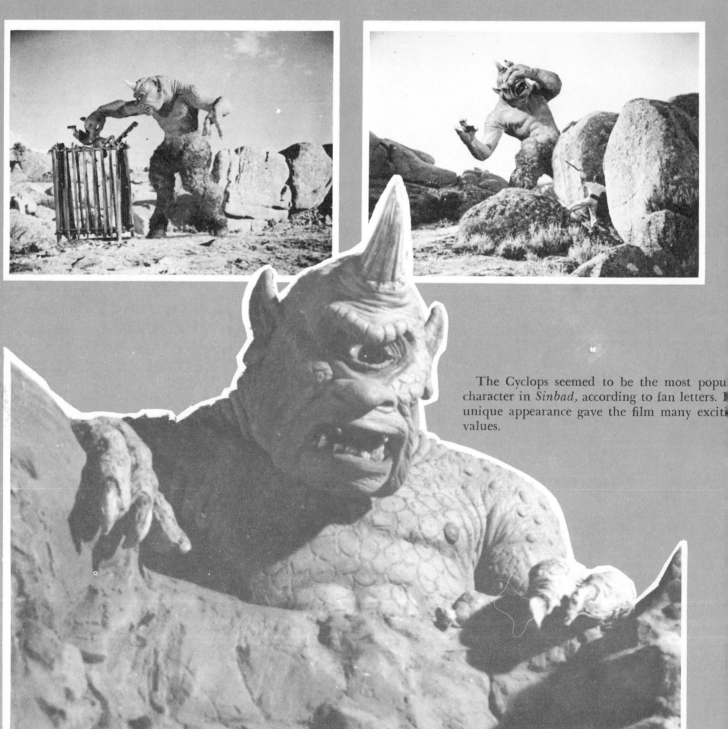

The Cyclops seemed to be the most popu[lar] character in *Sinbad*, according to fan letters. [Its] unique appearance gave the film many excit[ing] values.

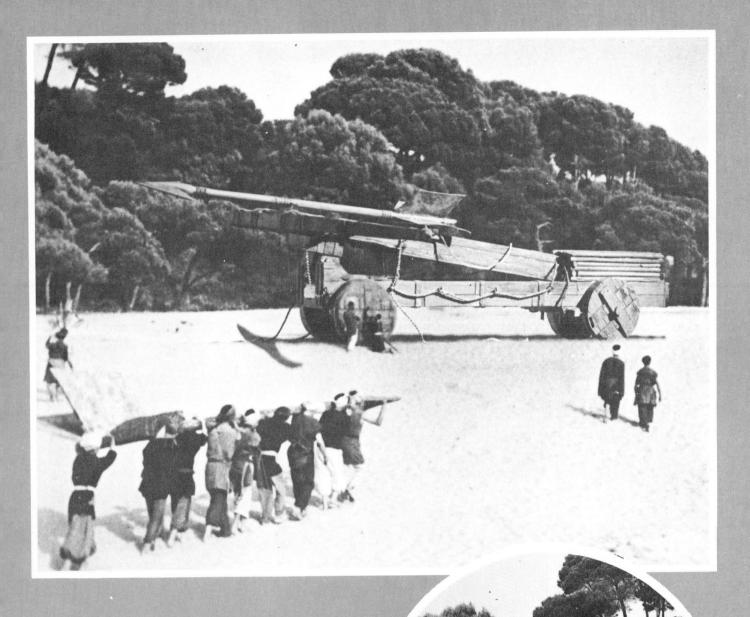

The giant crossbow was actually a miniature construction about two feet in length. On the beach at S'Agaro, in Spain, we only constructed one eight-foot wheel of the carriage of the machine. This wheel was large enough to act as a background for the actors who were performing in front of it. The only other section of the full-size crossbow that we had to construct was the 15-foot arrow seen in the foreground above.

All the performers had to be placed very carefully in exact positions to allow room for the inlay of the miniature. The later addition of the crossbow would not take place for many months.

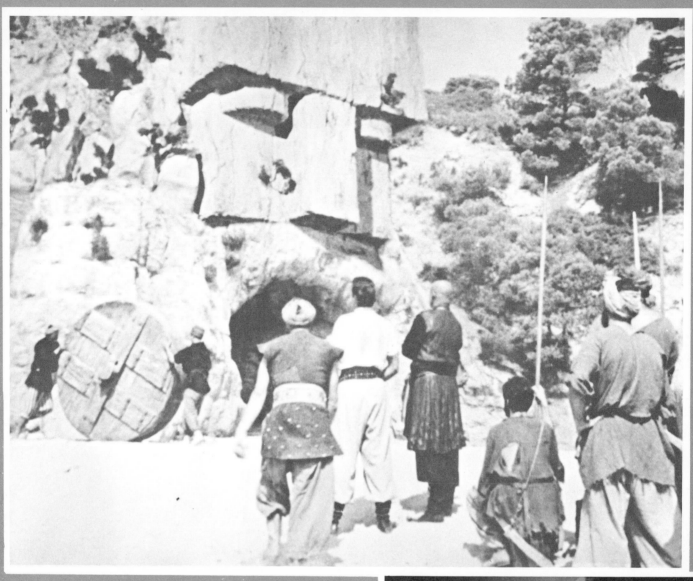

(Above) Another example of how, when on a tight budget, a company can save money on set construction by the use of partial miniature. The above stone face was "matted in" months later after the live action production was completed.

Most of *The Seventh Voyage of Sinbad* was photographed in Spain, on the Costa Brava, Granada, Majorca, and in and around Madrid. Pick-up shots including the interior of the magic lamp were finished in Hollywood. A minimum of only eight traveling matte shots were in the picture, all of which were photographed on the "Blue Backing" Technicolor process in London. A truly international picture.

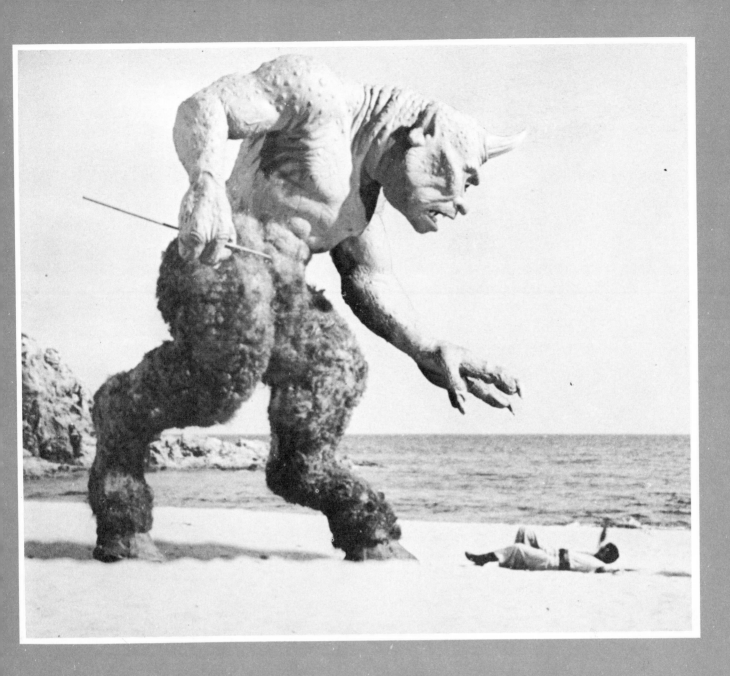

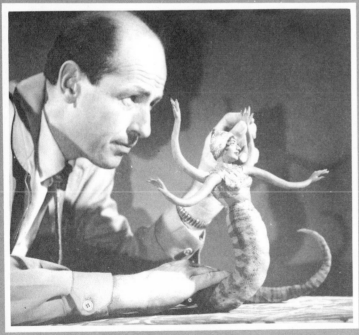

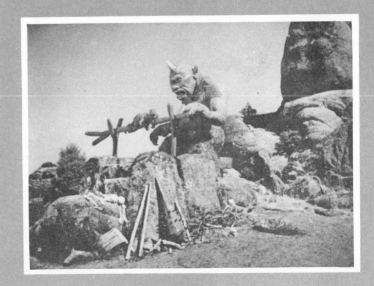

61

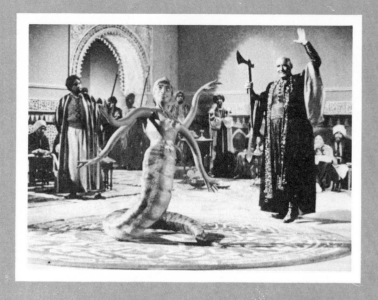
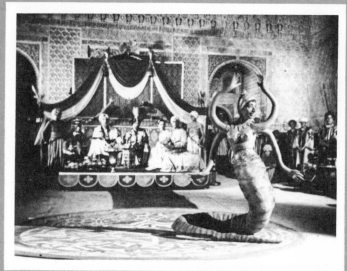
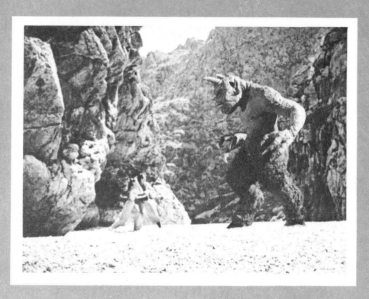
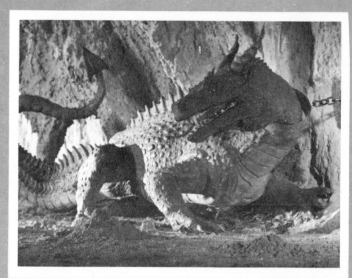
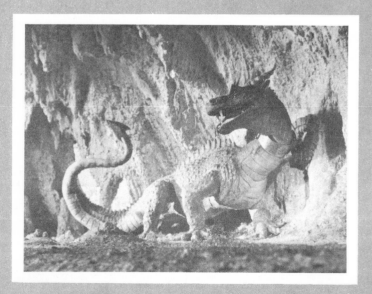
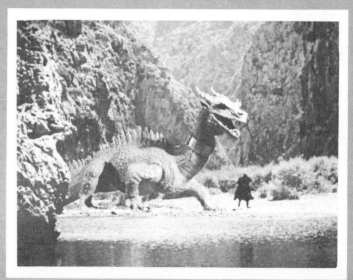

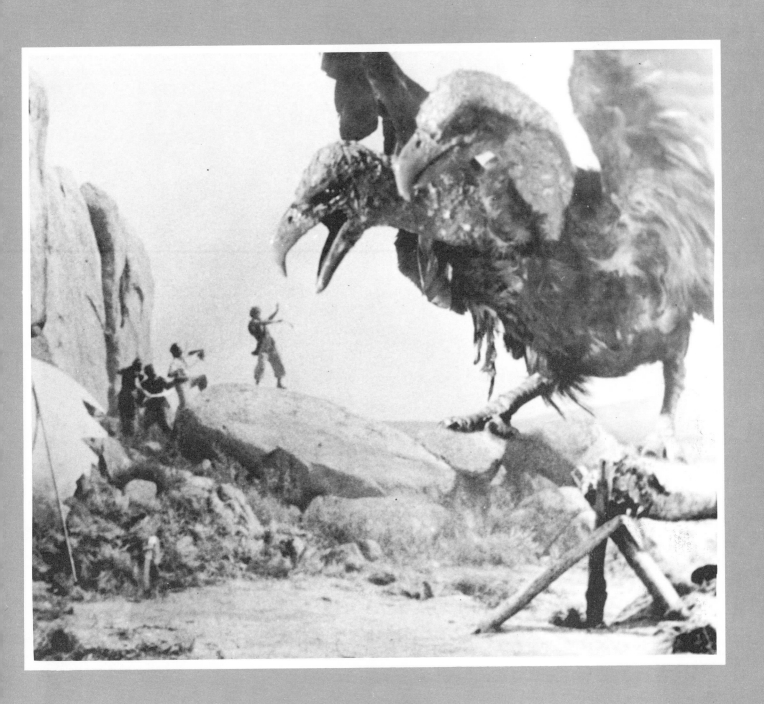

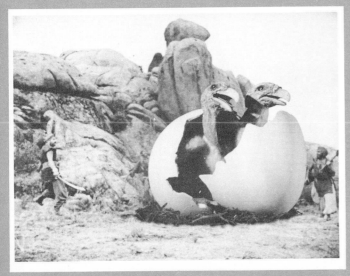

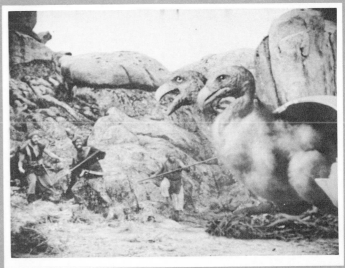

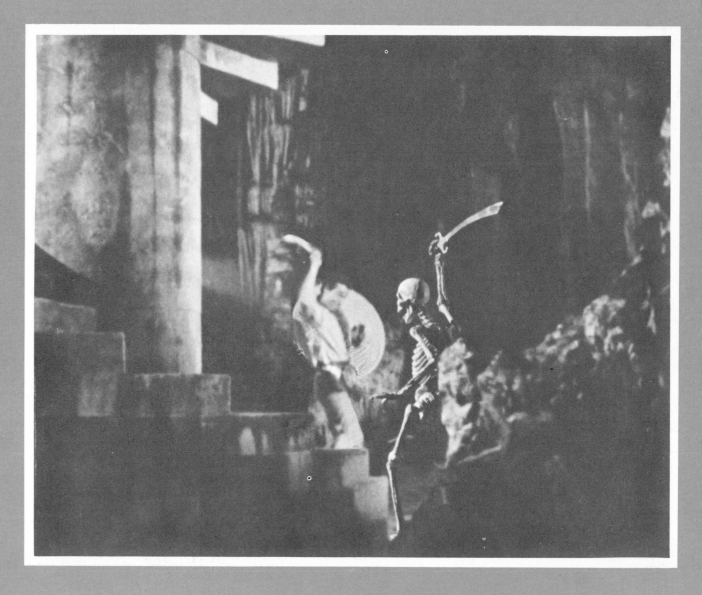

The Seventh Voyage of Sinbad was unique. Nothing quite like its contents had been seen on the screen before. The skeleton fight was the most talked about sequence of the picture. Bernard Herrmann contributed an outstanding "castanet concerto" that helped push the sword fight into classic dimensions. His score for the rest of the picture was just as startling and original. An exceptional musical accompaniment is a "must" for a film of fantasy.

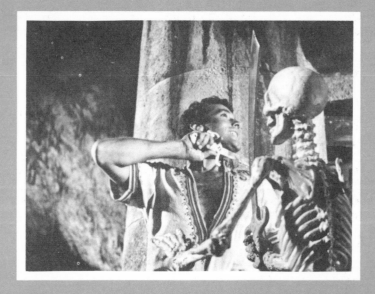

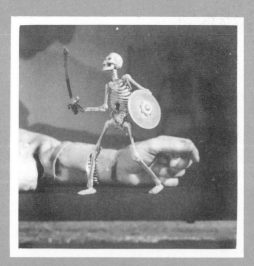

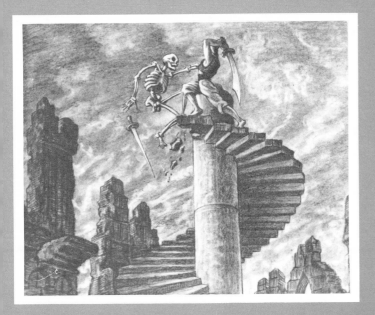 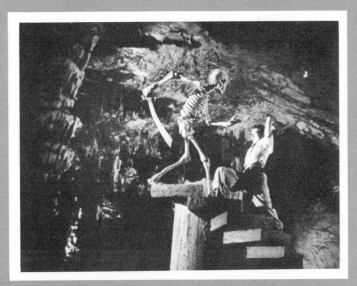

The skeleton fight was a rather complicated sequence to stage. We had the advantage of having that fine Italian Olympic fencing master Enzo Musumeci-Greco coach Kerwin Mathews as well as act out the part of the animated pile of bones. We then had to go through the same, split-timed routine again, this time without Enzo. It took many rehearsals to manage all the eye-lines of the three human characters to watch the same "imaginary" moving object. Kerwin was a master at giving the appearance that he was actually seeing the skeleton. It made my job much easier. As with the matte shots, it was months later when the animated skeleton was finally introduced into the scenes.

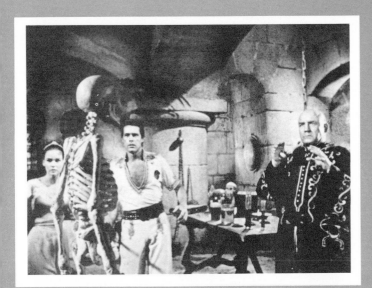 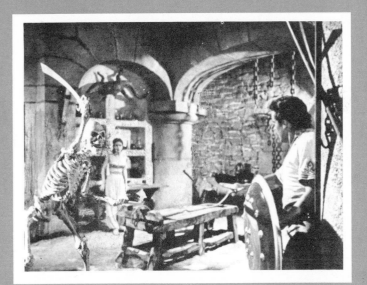

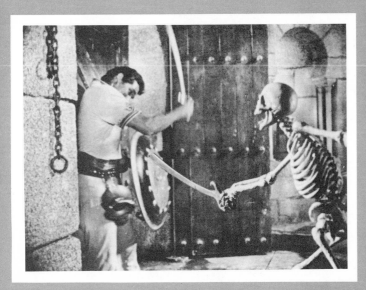 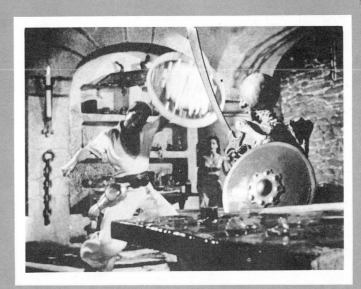

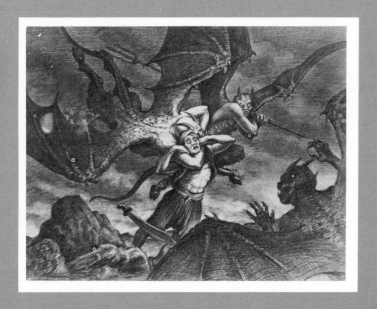

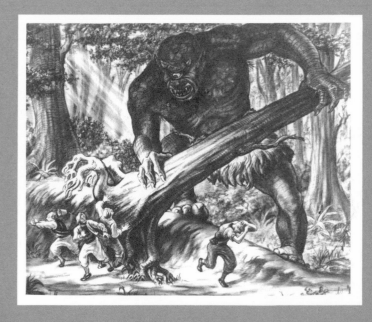

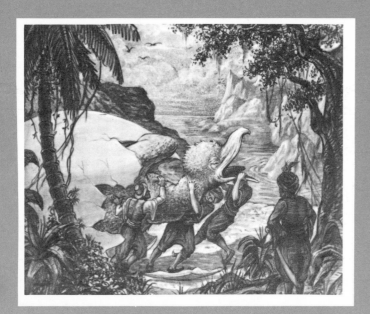

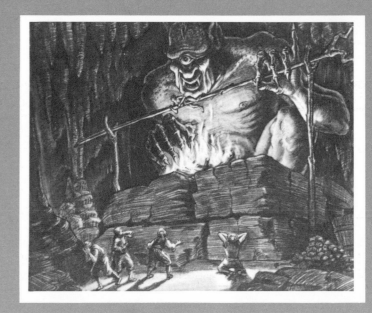

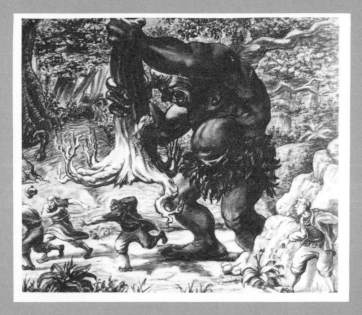

This page displays reproductions of some of my very early sketches that visualized the highlights of the overall proposed production. These sketches helped to sell the idea to Mr. Schneer as well as to the "Front Office." Later on, when the story had taken firm shape, many more drawings as well as a set of continuity sketches were used for guides in shooting. In the past, every time one mentioned animation, the public would immediately think of the animated cartoon. Charles Schneer and I therefore felt it was most important to establish a new name for the three dimensional animated medium combined with live-action. Hence the name *dynamation* was born.

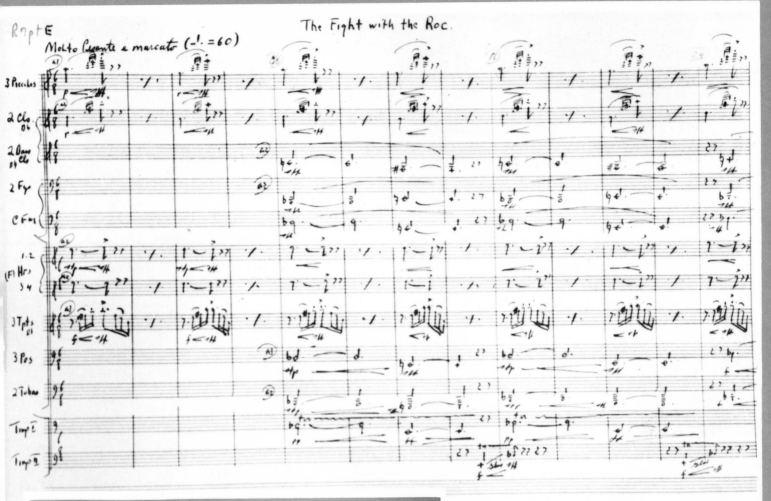

(Left) Bernard Herrmann's music is always a delight to hear, whether accompanying a film or on its own in the form of a recording. My admiration for his musical talents dates back to the 1936 radio series, *The Mercury Playhouse* by Orson Welles, which I listened to avidly every week.

When Charles first told me that he knew Bernie and was thinking about trying to sign him up to write the score for *Sinbad* I could not have been more pleased. One afternoon, at Columbia projection theatre, we ran the rough cut for him. Not much was said during the showing but the omens were good. Mr. Herrmann had not voiced one insulting remark about the picture as he is so often reputed to do. Although he came from the projection room with a rather grim expression on his face he apparently liked what he saw well enough to feel he could contribute something to it. And this "something" was most effective, as anyone who has seen the picture must readily admit.

Bernie disagrees, but in my opinion the music for *Sinbad* was one of his finest scores, at least of the music that he has composed for our films. His writing covers such a wide variety of different subjects that it is really invidious to compare any of them with one another.

(Above) Part of the unique score for Sinbad's fight with the two-headed Roc.

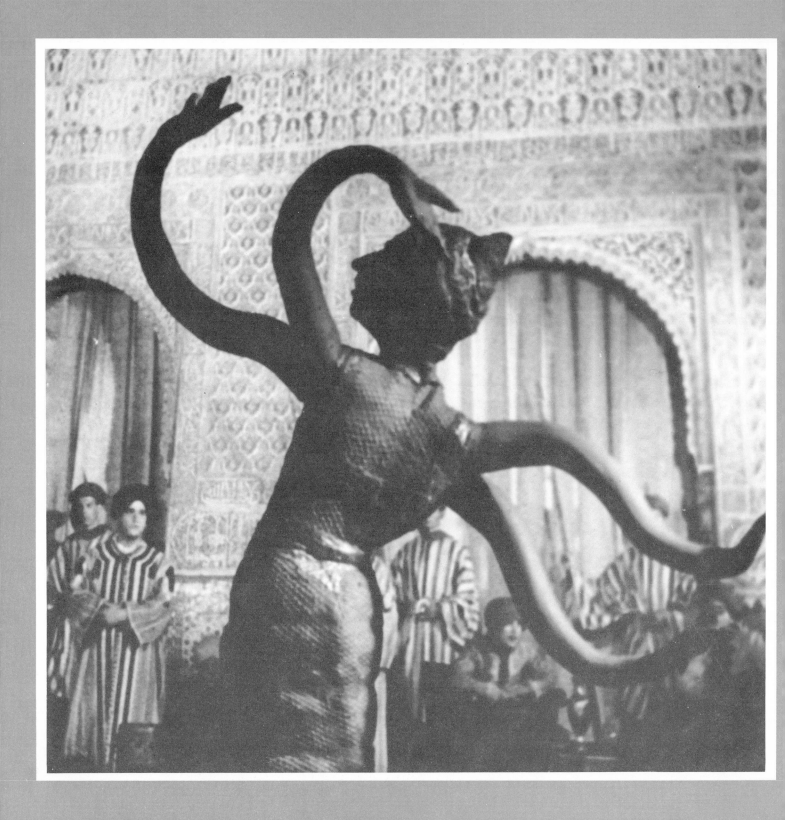

One of my favorite scenes, which is seldom acknowledged, is the sequence with the four-armed dancing snake-woman. In the story, Sokurah, the sorcerer, prepares an evening's entertainment of soothsaying and magic tricks for the Caliph. During his demonstration he turns the Princess's maid-servant into a creature—half woman and half snake. The main purpose for this theatrical manifestation was to set the stage, aiding the audience to better accept the strange magical powers that were so profusely used by the magician later in the film. Its secondary purpose was for pure, unusual, and eye-catching entertainment, a substitute for the traditional ubiquitous dancing girls who seem to find their way into most Arabian Nights' productions.

Wilkie Cooper's striking camera contribution to the film was full of many pitfalls which included a photographer's nightmare of constantly working with intermingled "dupe-negatives" and original color negatives. The lighting, particularly on interiors, had to be carefully adjusted to allow for secondary negatives. This means making sure the dark areas and highlight areas will look similar to the intercut original negative after duplication for the addition of the special effects. Today, new fine-grain raw stocks have been developed, that help enormously to overcome this problem. In 1957, when *Sinbad* was in production, there was little to choose from in the way of special reproduction film.

The Three Worlds of Gulliver

After the success of *The Seventh Voyage of Sinbad*, Charles Schneer and I decided to do the story of Gulliver. It was later released under the title of *The Three Worlds of Gulliver*.

It was almost impossible to make the picture in Hollywood, not only because of the cost factor but because of certain technical problems. New and fresh locations were also important to the project.

Britain had, for several years, a special traveling matte approach developed by the Rank Organisation called the Sodium Backing Process. (Traveling matte is a means of combining two separately photographed scenes into one picture.) Unlike the old Blue Backing technique we used in *Sinbad*, the sodium method made an instantaneous matte in a split-beam camera. The Blue Backing process required from eight to ten different steps to produce a proper matte, which needless to say is very time-consuming. (Since the making of *Gulliver*, Technicolor has developed its process into a much quicker and better method.) Each process has its advantages depending on the subject and necessities of the individual picture.

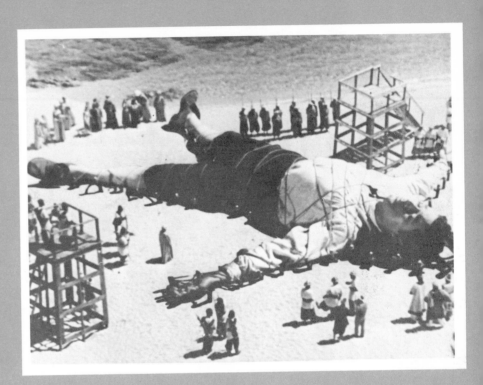

At that time the advantages of sodium were enormous, particularly to a project where we had a great number of special scenes to photograph. Also, choice of colors used in foreground shooting was unrestricted. In the Blue Backing method it was necessary to avoid any costume or foreground piece with blue in it. Delicate lines such as thin ropes or netting used in the foreground presented a big problem too. The sodium process minimized these difficulties, if not eliminating them altogether, giving us a much wider variety of foreground choices of composition and color. This is enormously important to a film such as *Gulliver*.

(Top) This picture was produced by means of traveling matte.

(Left) An example of perspective photography.

 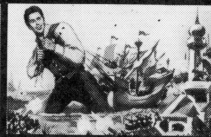 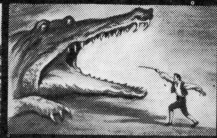
 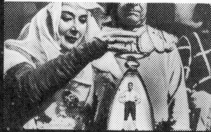

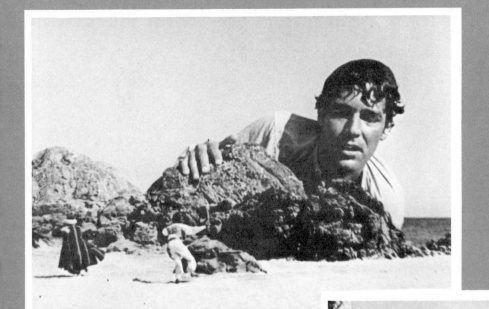

(Left and below) Two examples of split-screen technique. Split-screen is used to combine two or more separate pieces of film where the action does not overlap. Gulliver (Kerwin Mathews) was photographed at close range on a miniature set and the Lilliputian effect was obtained by shooting normal people at a distance. The two pieces of film are then carefully combined in an optical printer.

The production planning is most intricate for scenes such as these, as each half of the picture has to be scheduled for shooting at different periods of time. The first half shot must be developed before the second half can be lined up. The actors have nothing to react to except their own imagination and key positions for their eye line. The direction of the sunlight also is a necessary factor to consider in order to create a convincing compound picture.

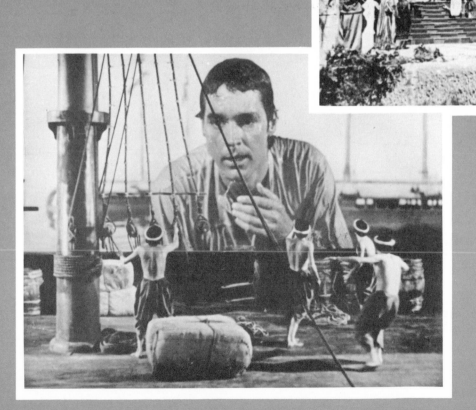

(Left) Where the action does overlap it is necessary to use traveling matte. This shot was achieved in a similar way as the above only with a different technique. Gulliver was photographed close-up against an appropriate background and the foreground people and deck were recorded at the necessary distance to make them seem small. The foreground set was shot against a sodium (yellow) background. A special Beam-Splitter optical printer is employed to put the two pieces together.

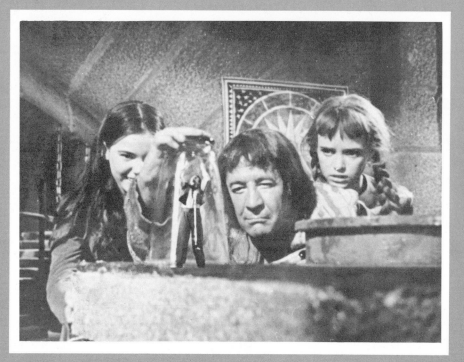

(Left) Makovan (Charles Lloyd Pack) tures Gulliver in a battle. Once again trave matte was used to reduce Gulliver in size. scene required special attention as it was portant that the little figure appear to be tually inside the jar.

(Below) Actor Kerwin Mathews sits in miniature setting, which gives him the app ance of being unusually large.

(Right) Glumdalclitch (Sherri Albero peers into a miniature window at Gulliver Elizabeth (June Thorburn). Split-screen used to produce this effect.

72

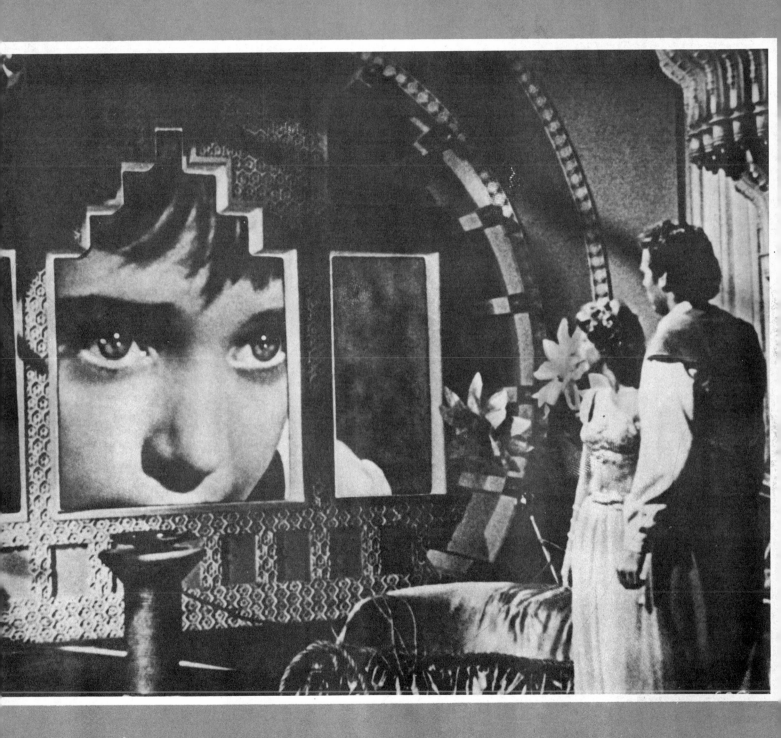

Building over-size set pieces has been employed by film-makers since the silent days. It is most effective for closer-type shots but is basically limited for total use in a complete film. In *The Three Worlds of Gulliver* we had a sequence in which Gulliver tries to beat the giant King of Brobdignag at chess. The sequence was quite long and important to the story, warranting the cost of building detailed and enlarged set pieces. But if one continually employs nothing but enlarged props and scenery the illusion of comparative size would soon disintegrate unless combined with other processes such as traveling mattes or split screen that can introduce live action to a shot. It is this combination of various processes, used with discretion, that adds up to the creation of the final illusion.

The Three Worlds of Gulliver called for every trick effect in the book plus many more that had to be created. One simply cannot create a formula for a story of this kind. A major problem is that all these various processes can cost a lot of money unless carefully planned. It is my contention that "anything" can be done in the cinema providing there is unlimited money and time for completion. The problem in our sometimes over-ambitious films has always been how to get the maximum illusion for the subject matter on a minimum budget and time schedule. This can only be accomplished by careful planning and controlled production. I have no doubt that many of the subjects we have chosen to film would cost three to four times as much to produce if attempted by a major studio. And it is debatable if the "improvement" would really justify the cost.

(Above) Charles Schneer and I prepare all of our pictures together with a great deal of care. Our scripts are broken down into far more detailed shots than the "normal" shooting script.

(Right) During our shooting on the *Three Worlds of Gulliver* we found it imperative to keep the camera angles low in order to give the giant world of Brobdignag a sense of grandeur. This often meant digging holes in the sand, almost burying the camera, in order to keep the proper perspective.

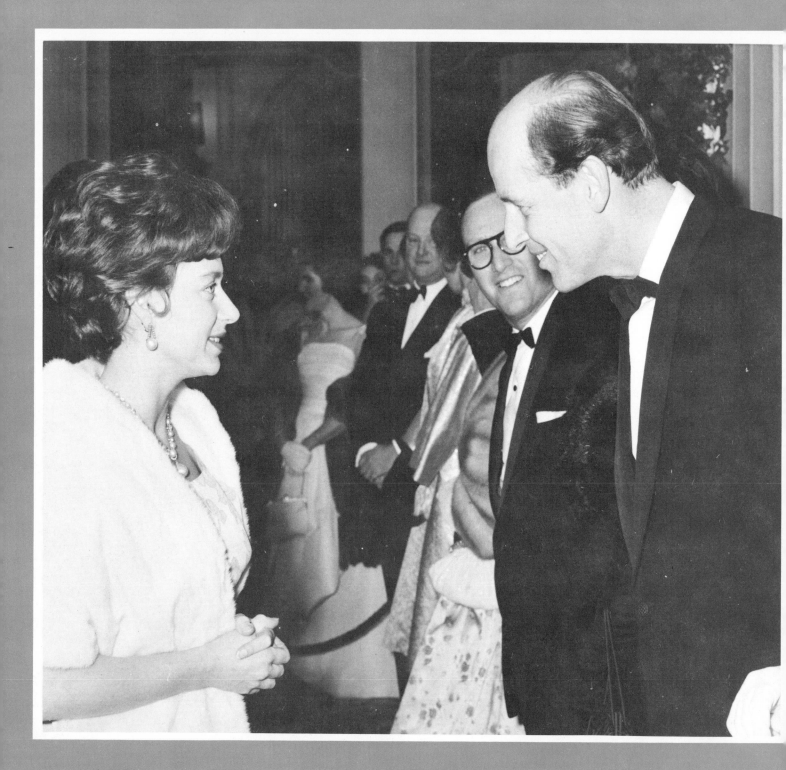

The British premiere of *The Three Worlds of Gulliver* was held at the Odeon Marble Arch Cinema on Wednesday, November 30th, in aid of the N.S.P.C.C. in the presence of H.R.H. Princess Margaret. Mr. Ray Harryhausen talking to H.R.H. Princess Margaret.

Mysterious Island

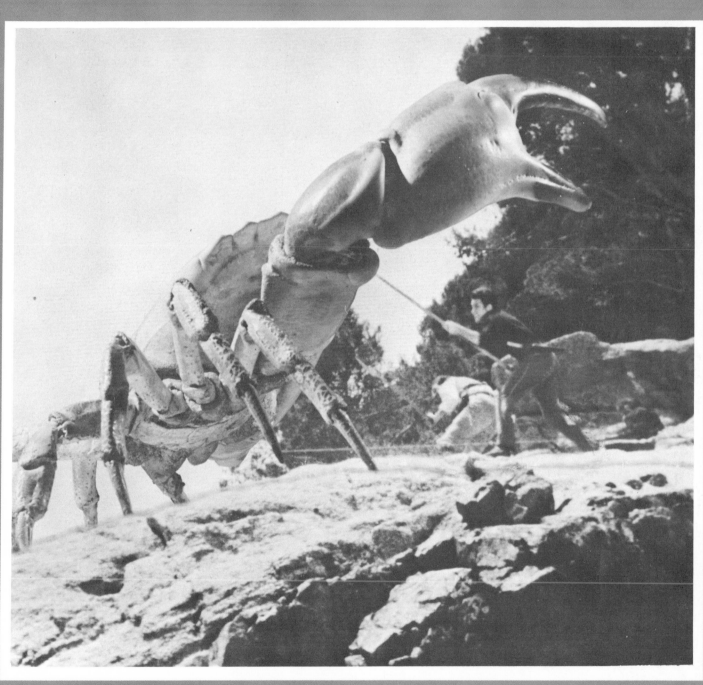

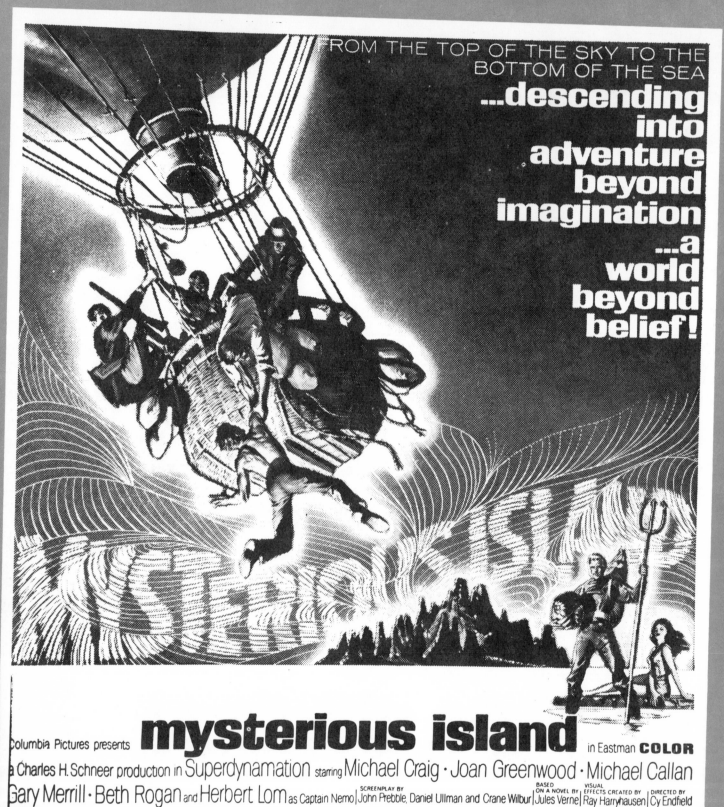

FROM THE TOP OF THE SKY TO THE
BOTTOM OF THE SEA
...descending
into
adventure
beyond
imagination
...a
world
beyond
belief!

mysterious island

in Eastman COLOR

Columbia Pictures presents

a Charles H. Schneer production in Superdynamation starring Michael Craig · Joan Greenwood · Michael Callan

Gary Merrill · Beth Rogan and Herbert Lom as Captain Nemo | SCREENPLAY BY John Prebble, Daniel Ullman and Crane Wilbur | BASED ON A NOVEL BY Jules Verne | VISUAL EFFECTS CREATED BY Ray Harryhausen | DIRECTED BY Cy Endfield

an Ameran film

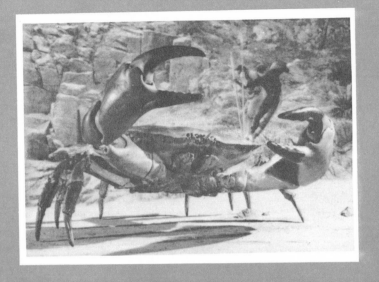

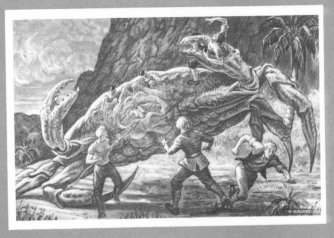

Mysterious Island was from a Jules Verne novel and actually a sequel to *20,000 Leagues Under the Sea*. Although we took certain liberties by altering the story to include gigantism for more visual excitement, we maintained as much of Verne's original idea as was possible. The balloon sequence at the beginning was quite unusual and dynamic photographically. Most of it was done on a "yellow backing" screen in the studio along with the help of miniatures.

(Right) Pre-production sketches from some of the highlights of the picture.

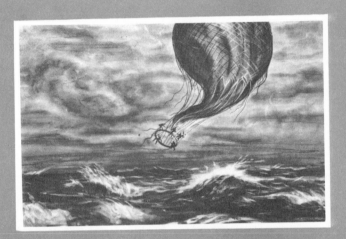

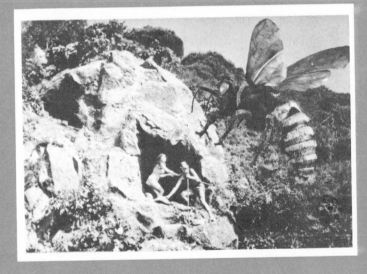

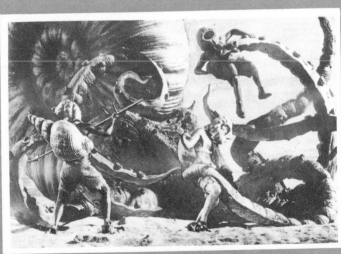

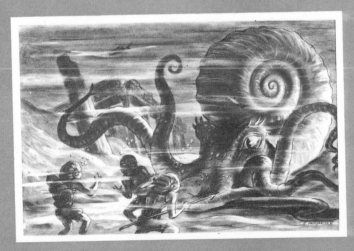

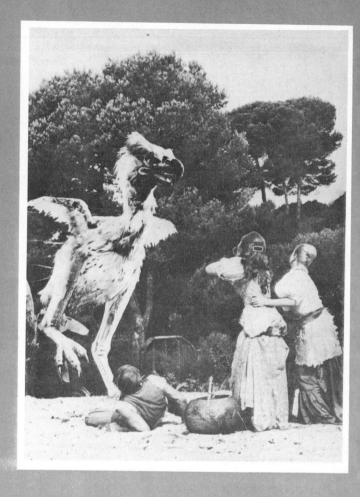

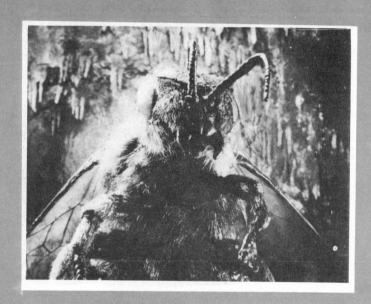

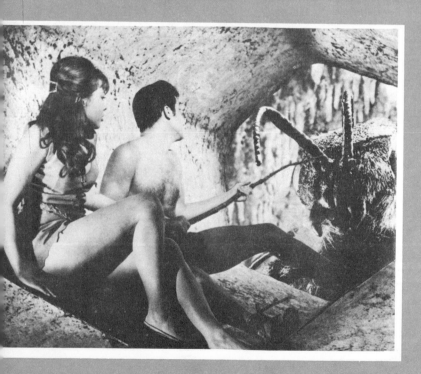

(Upper left) Example of a foreground "set-piece" representing an enlarged section of one cell of a giant honeycomb. It was constructed of fiberglass to give the slightly translucent appearance. Through the hole, opening in the background, was a sodium-lighted (yellow) screen. Months later a close shot of an animated miniature bee was recorded for the background. The third picture (left) shows the final result of the completed traveling matte.

(Above) A prehistoric Phororhacos menaces Joan Greenwood, Gary Merrill, and Beth Rogan. Originally, the bird was supposed to have an antediluvian background, but owing to some script deletions its origin was discarded. Most reviewers and audiences assumed it to be an overgrown chicken. Its awkward movements turned it into a "comedian." However, a good laugh in the story was a pleasant relief from all of the melodramatic thrills of the rest of the film.

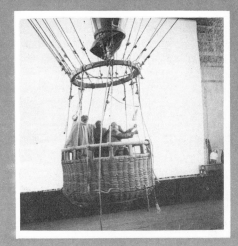

(Above right) Another example of the foreground balloon ring and basket being photographed against a yellow backing. In the final print a moving sky background or turbulent sea will appear behind the actors.

(Above left) The same process applies to the portions of the submarine where an enormous cave setting will appear behind the machine.

(Below) Charles Schneer and Ray Harryhausen during shooting of one of the sea scenes.

(Below right) The giant nautiloid cephalopod menaces the divers in *Mysterious Island*. A part of this scene was actually photographed under water and later combined with the animated creature. The tentacles required almost microscopic movements in order to give the illusion of a slow undersea effect.

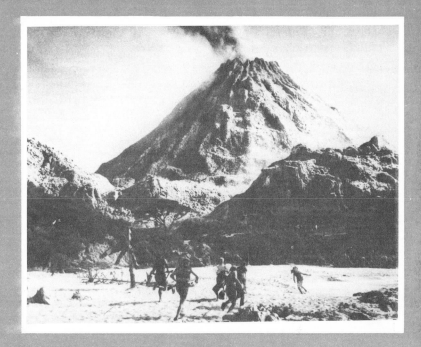

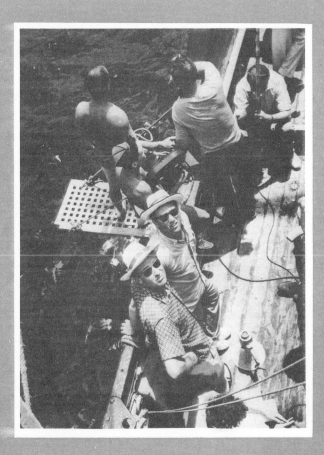

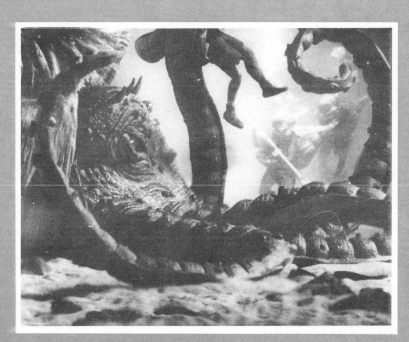

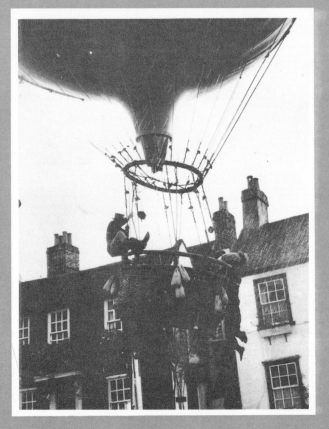

(Above) The opening of *Mysterious Island* was photographed in Shepperton Square. It was a quiet place to work and resembled certain areas of the southern United States during the Civil War period. Only a portion of the full-size balloon was constructed, as a complete one would have been far too difficult to control. A large crane was employed to give the movement and sense of ascension of the basket. The storm effect was created by the use of a number of fire hoses as well as large wind machines.

(Lower right) Charles Schneer and Ray Harryhausen talk over some of the sequences during a pre-production meeting.

(Lower left) The Crab sequence was one of the highlights of *Mysterious Island*. Once again, the actors had to "shadow box" an imaginary beast when they were performing in front of the cameras. This sequence was one of my favorites. The music scoring was particularly appropriate and almost unique, counterpointing the action in a most effective way.

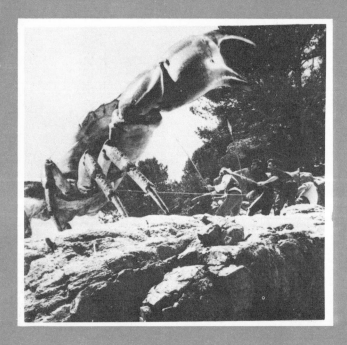

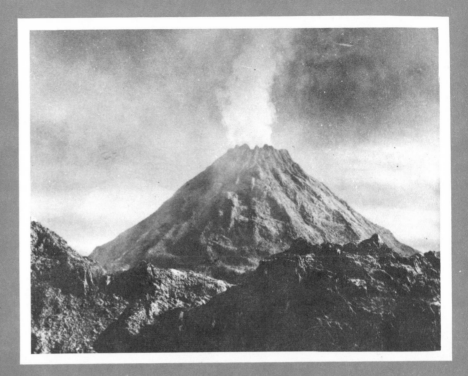

(Above) A miniature volcano was constructed, about six feet high, for the climax of the picture. The smoke, of course, on a set of such small size would move far too fast, thus destroying the scale illusion. Wilkie Cooper, who has been the Director of Photography on most of our films had to shoot the scene at 96 frames per second to slow down the smoke. This not only gave the impression of great distance but added to the effect of mass as well.

(Below) Captain Nemo's submarine was ten feet in length with the background carefully to scale. Once again, for the movement of the water and final collapse of the cave, we had to shoot the miniature at 96 frames per second to achieve a realistic look. Shooting four times normal speed requires four times as much light as normal speed. In earlier scenes, traveling matte was employed to place real people on the bridge and on top of the miniature submarine.

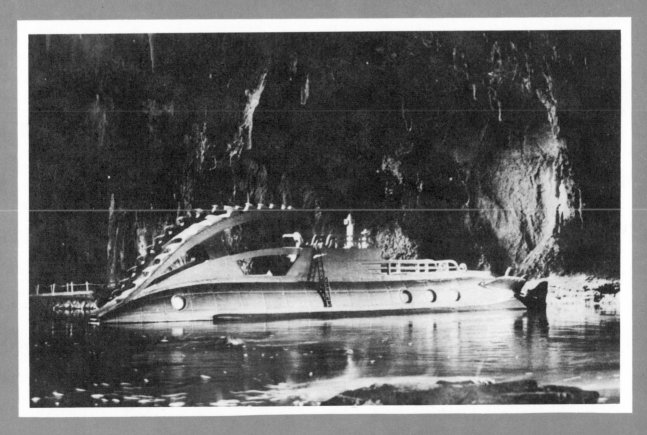

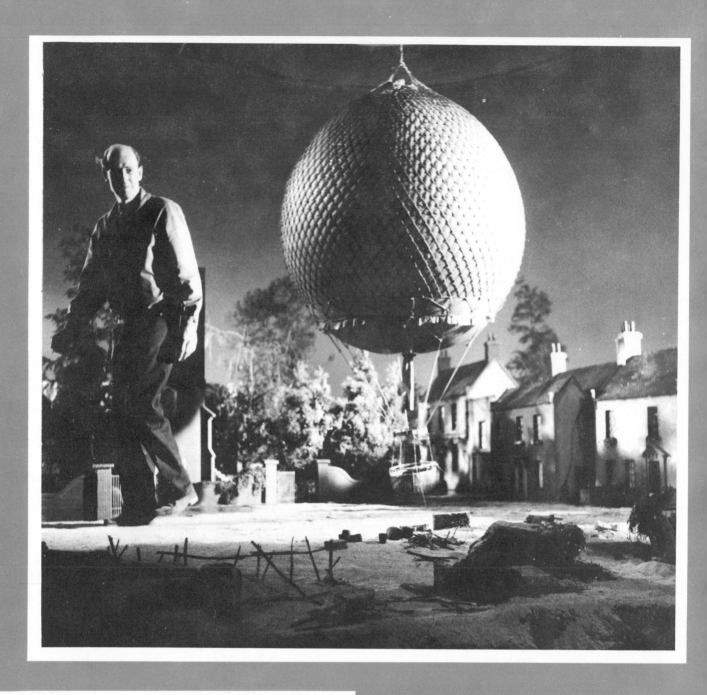

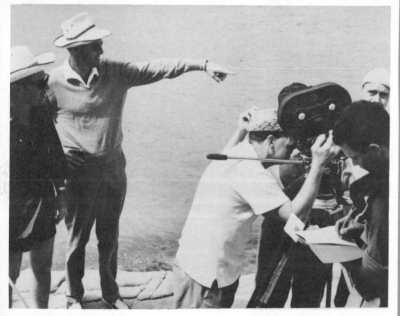

(Above) In the opening of the picture the script called for a long shot of a grounded Army balloon buffeted about by wind and rain. Although we shot the closer scenes of the storm in Shepperton Square, it was impractical and far too expensive to build a full-size balloon and soak the square with an all-out storm effect. It became necessary in order to get this long shot, to build a duplicate of the Square in miniature for full control. People were later added to the shot by means of traveling matte to give it more realism. In the end, it was far more effective a scene than anything that could be staged in full size.

(Left) Charles Schneer and I discussing a shot for a scene in *Mysterious Island*. Bernard Herrmann scored the film with his most impressive style of music.

Jason and
the Argonauts

Of the 13 fantasy features I have been connected with I think *Jason and the Argonauts* pleases me the most. It had certain faults, but they are not worth detailing.

Its subject matter formed a natural story line for the Dynamation medium and like *The Seventh Voyage of Sinbad* strayed far from the conventional path of the "dinosaur exploitation film" with which this medium seemed to be identified.

Taking about two years to make, it unfortunately came out on the American market near the end of a cycle of Italian-made dubbed epics based loosely on the Greek-Roman legends, which seldom visualized mythology from the purely fantasy point of view. But the exhibitors and the public seem to form a premature judgment based on the title and on the vogue. Again, like *Sinbad*, the subject brewed in the back of my mind for years before it reached the light of day through producer Charles Schneer. It turned out to be one of our most expensive productions to date and probably the most lavish. In Great Britain it was among the top ten big money makers of the year.

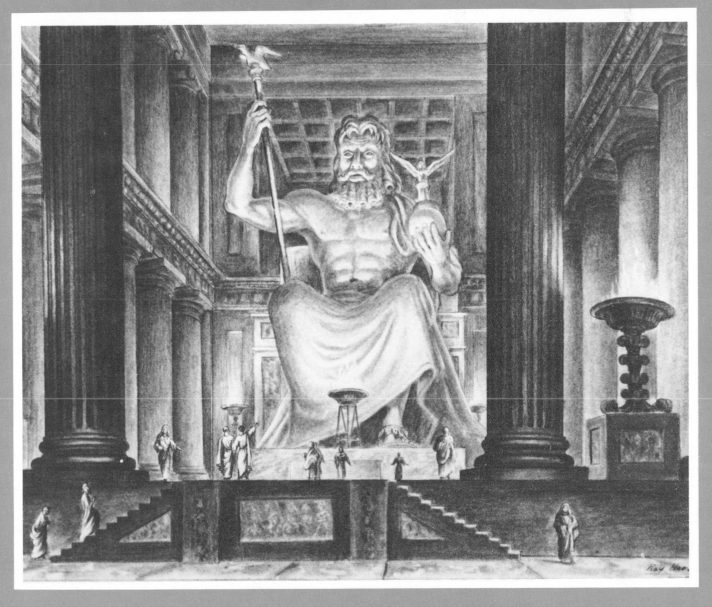

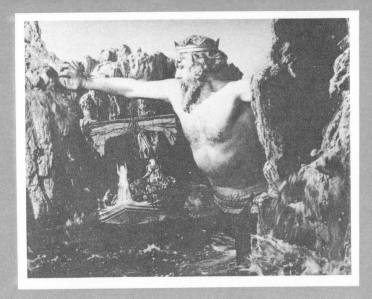

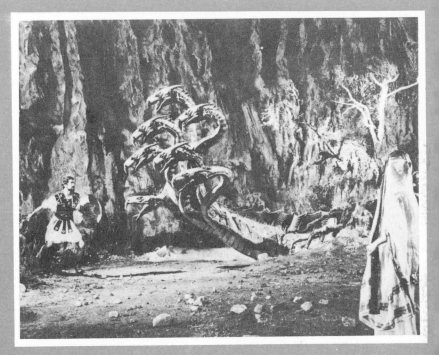

(Left) Three drawings of pre-production sketches I made for *Jason* showing some of the highlights of the sequences. (Right) The counterparts from frames of the production. Some of the difference in basic composition is the direct result of compromising with available locations. For example, the ancient temples in Paestum, southern Italy, finally served as the background for the "Harpy" sequence. Originally we were going to build the set when the production was scheduled for Yugoslavia. Wherever possible we try to use an actual location to add to the visual realism. To my mind, most overly designed sets one sees in some fantasy subjects can detract from, rather than add to, the final presentation. Again, it depends on the period in which it is made as well as on the basic subject matter. Korda's *The Thief of Bagdad* was the most tastefully produced and designed production of any film of this nature but unfortunately the budget that was required would be prohibitive with today's costs.

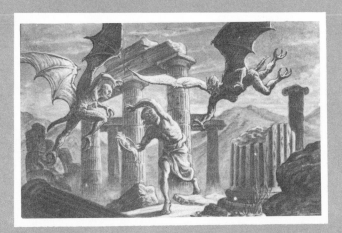

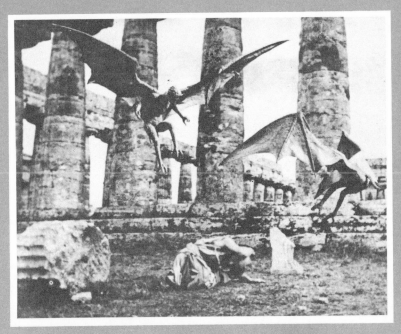

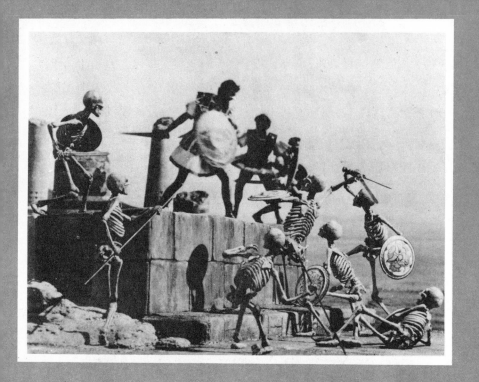

The Skeleton Sequence was the most talked-about part of *Jason*. Technically, it was unprecedented in the sphere of fantasy filming. When one pauses to think that there were seven skeletons fighting three men, with each skeleton having five appendages to move each frame of film, and keeping them all in synchronization with the three actors' movements, one can readily see why it took four and a half months to record the sequence for the screen. Certain other time-consuming technical "hocus-pocus" adjustments had to be done during shooting to create the illusion of the animated figures in actual contact with the live actors. Bernard Herrmann's original and suitably fantastic music score wrapped the scenes in an aura of almost nightmarish imagination. My one regret is that this section of the picture did not take place at night. Its effect would have been doubled.

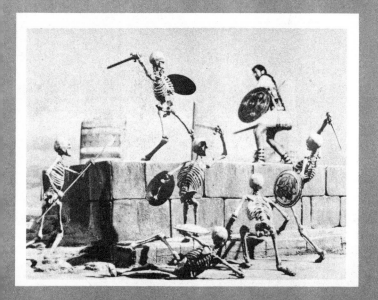

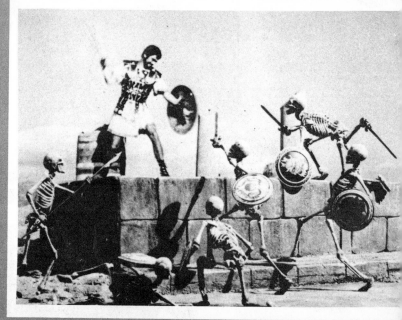

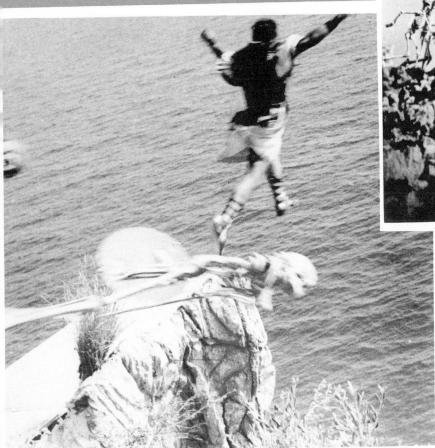

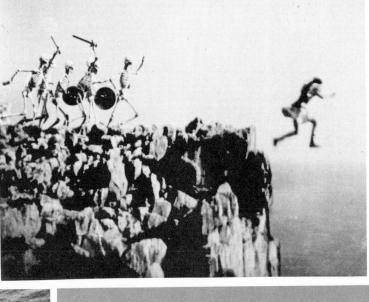

In the story, Jason's only way of escaping the wild battling sword wielding "children of Hydra's teeth" is to leap from a cliff into the sea. (Above) A stuntman, portraying Jason for this shot, leaps from a 90-foot-high platform into the sea closely followed by seven plaster skeletons. It was a dangerous dive and required careful planning and great skill. It becomes an interesting speculation when dealing with skeletons in a film script. How many ways are there of killing off death?

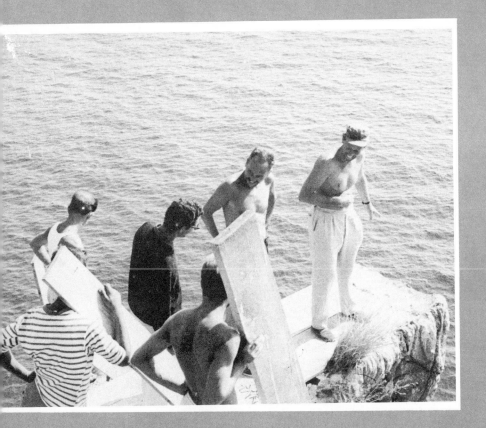

(Above right) Another angle with the *real* Jason jumping off a wooden platform into a mattress a few feet below. The skeletons and the rocky cliff were put in afterwards while the mattress was blotted out by an overlay of sea.

(Left) Director Don Chaffey and Ray Harryhausen discuss the leap with Italian stunt director Fernando Poggi.

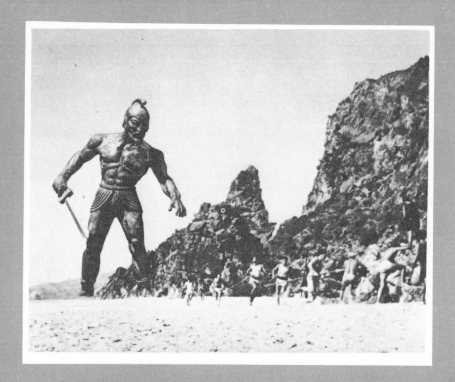

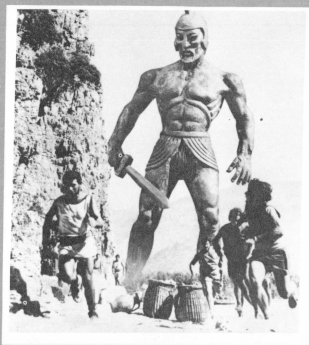

When transferring published material to the screen it is almost always necessary to take certain liberties with the work in order to present it in the most effective visual terms. Talos, the man of bronze, *did* exist in the Jason legend, although not in the gigantic proportions that we portrayed him in the film. My pattern of thinking in designing him on a very large scale stemmed from research on the Colossus of Rhodes. The action of his blocking the only entrance to the harbor stimulated many exciting possibilities. Then too, the idea of a gigantic metal statue coming to life has haunted me for years, but without story or situation to bring it about.

It was somewhat ironical when most of my career was spent in trying to perfect smooth and life-like action and in the Talos sequence, the longest animated sequence in the picture, it was necessary to make his movements deliberately stiff and mechanical.

Most of *Jason and the Argonauts* was shot in and around the little seaside village of Palinuro, just south of Naples. The unusual rock formations, the wonderful white sandy beaches, and the natural harbor were all within a few miles of each other, making the complete operation convenient and economical. Paestum, with its fine Greek temples, was just a short distance north. All interiors and special sets were photographed in a small studio in Rome.

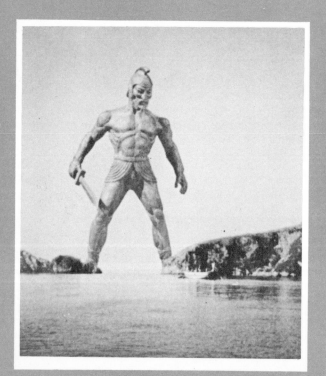

(Above) Talos, the statue of bronze, pursues Jason's men.

(Lower left) Talos blocks the Argo from the only exit of the bay.

(Lower right) Pre-production drawing of Jason speaking to the Gods of Greece.

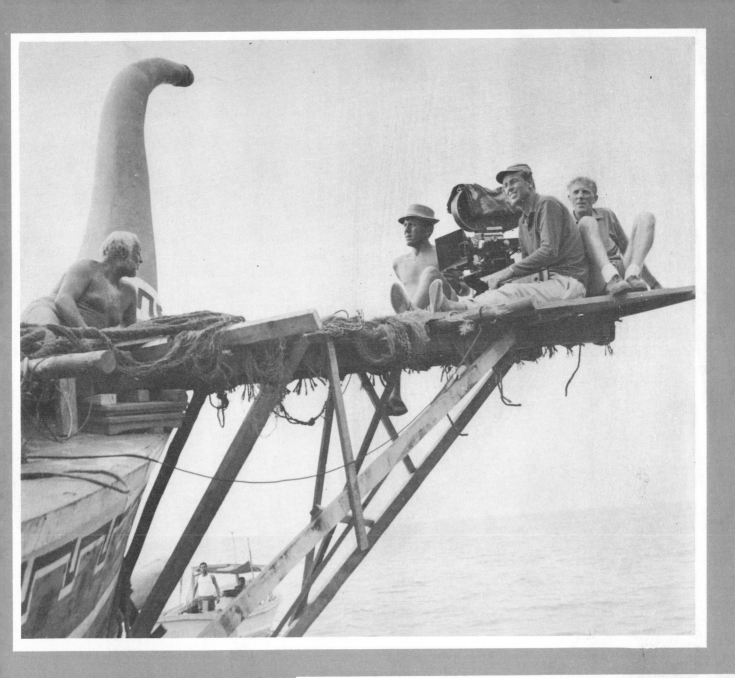

(Above) For the second unit operation a special platform had to be fitted to the Argo in order to achieve certain camera angles. Although it looks precarious it was far more convenient than using another boat for the shots.

(Right) The Argo had to be above all practical in the sense that it must be seaworthy as well as impressive. It was specially constructed for the film over the existing framework of a fishing barge. There were twin engines for speed in maneuvering, which also made the ship easily manipulated into proper sunlight for each new set-up.

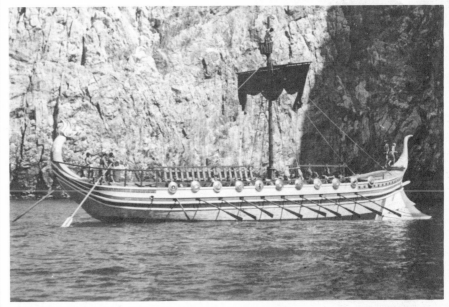

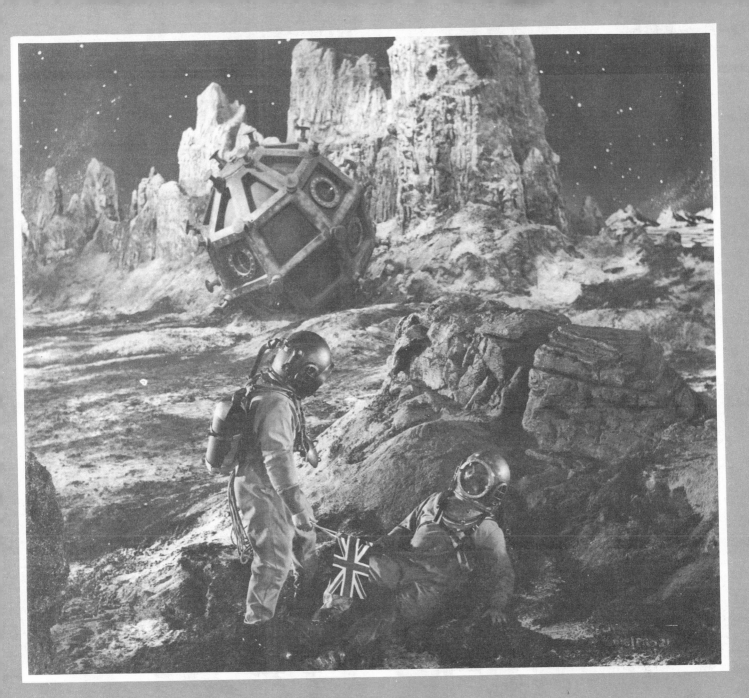

First Men in the Moon

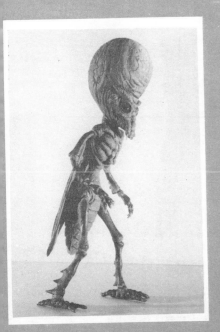

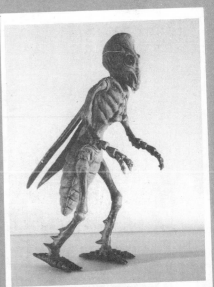

(Above) The Space-Sphere after making a three-point landing on the moon.

When I heard Charles Schneer wanted to shoot *First Men in the Moon* in a wide screen process I cringed. Although a number of experiments were made, the process I employed in previous films simply could not be used to any extent in an Anamorphic system. At the time it was felt by all the "Powers that be" that a wide screen system would be an added box-office attraction.

(Left and right) Because the film was finally shot in an Anamorphic process, hardly any stills were made of the special effects work. These are two rare photographs of the Grand Lunar and one of the "insect" moon men.

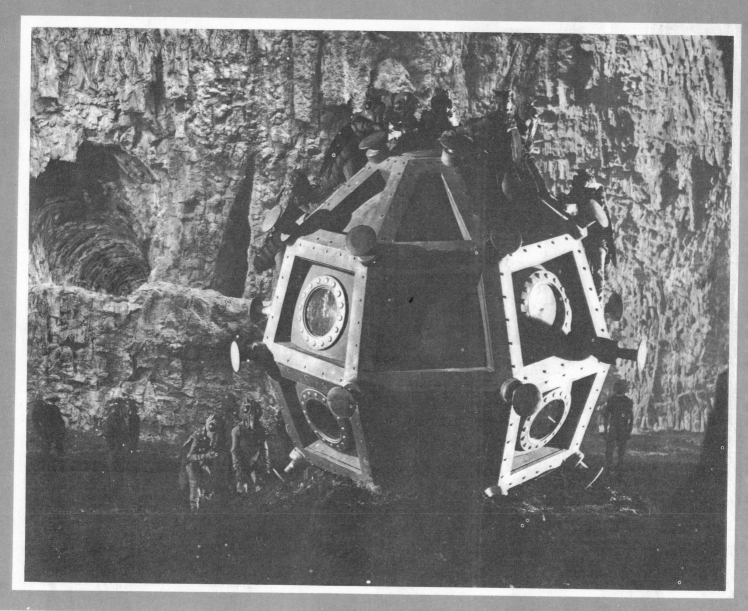

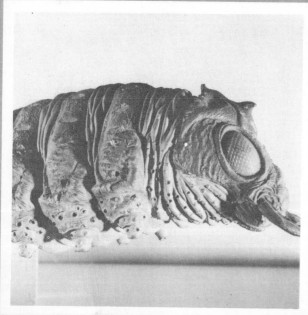

It was important to give the film an impressive appearance as we dealt with a subject matter that required putting on the screen a complete "Alien Civilization" with a comparatively nominal budget. I felt the only way this could be done was to build all the spectacle set pieces in miniature and incorporate the people into them with the aid of traveling matte. This was done with most of the key shots and, I think, to impressive effect.

(Left) The head of the "mooncalf." (Above) I have never been an advocate of "men in suits" to represent animaloid creatures, but with our project the script called for masses of insect-like beings swarming over the Space-Sphere. To avoid an eternity in animating the creatures en mass I found it necessary to build insect suits in which we placed small children. Almost all close-ups were done with the animated figures. Fortunately the low key lighting allowed us to use the suits successfully. The Space-Sphere was designed as closely as possible to H. G. Wells's description in his novel. On deeper analysis it was fascinating how practical the concept was, providing of course that one *could* devise a paint that would actually alleviate gravity. Therein lies the rub.

(Bottom left) Ray Harryhausen being pursued by one of his own monsters, the "mooncalf."
(Bottom right) Martha Hyer is shocked by the first sight of one of the "Selenites."
(Upper left) Director Nathan Juran and actor Lionel Jeffries discuss one of the scenes.
(Upper right) The Space-Sphere had to be transported to the set by a huge crane. In the screen story, the Sphere was supposed to have been constructed by a slightly "mad" scientist, Cavor, out of an old diving bell that had been modified with movable blinds and "railway" bumpers. The bumpers were used to absorb the shock of landing on the moon. Visually it seemed quite acceptable.

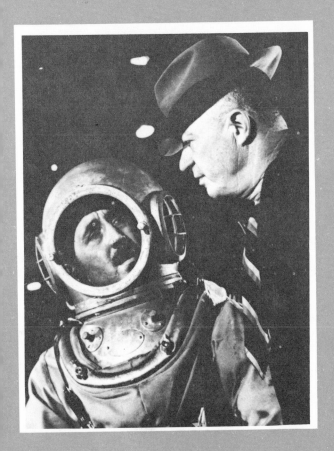

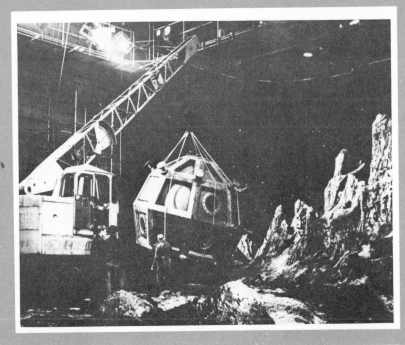

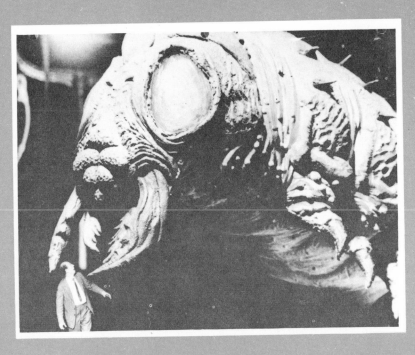

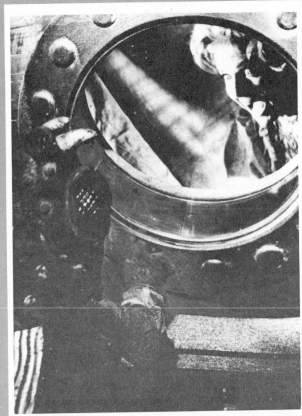

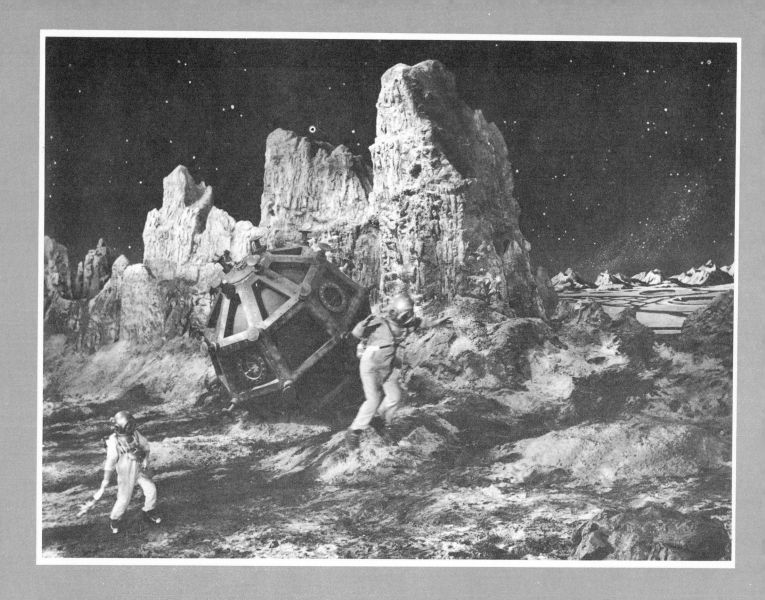

(Above) A large section of "moonscape" was built on the silent stage at Shepperton. Our moon was scientifically accurate by being airless on the surface. In our story, the Victorian explorers use diving suits as space attire for their lunar adventures. As the dialogue so appropriately states, "What will keep water out, will keep air in." It really sounds most logical.

(Below) One of the entrances to the interior of the moon. The "Selenites" drag the Space-Sphere through the large doorway.

(Above) Ray Harryhausen and Charles Schneer talk to Frank Wells, son of H. G. Wells, when he visited the set of *First Men in the Moon* at Shepperton Studios.

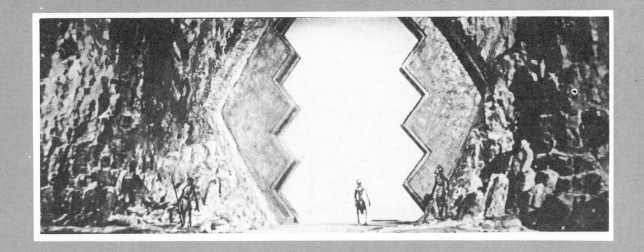

Inasmuch as the moon people were insect-like, all door apertures were designed as hexagonal, similar to nature's concept of a bee honeycomb or other insect structures. (Above) Foreground for traveling matte miniature before real people and bubbling vats were put into the background. (Center) The miniature was used as one half of a split screen. The center door, stair case, and live actors were later combined. (Bottom) One phase of double printing: the light rays were directed downward, hitting the mirror, then penetrating deep into the tunnel.

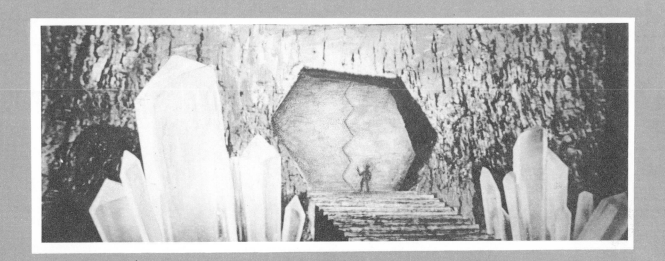

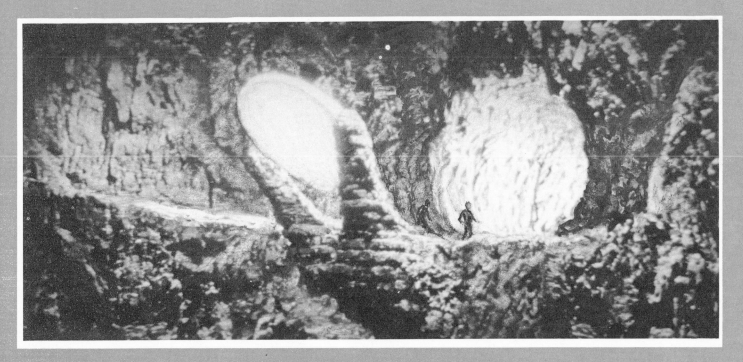

H. G. Wells, in his 1900 novel, suggested there could be air on the surface of the moon, but with present-day knowledge available to everyone we found it necessary to keep to the scientific concept in order to prevent all the visual situations from becoming completely unbelievable. But of course there really was no logical reason why we could not have air generated inside the caverns of the moon. The design of the great bubbling vats that separated the oxygen from the H_2O, the saw-tooth sliding doors, the involved lenscomplex with the projected beams of light were the result of following through with this basically logical concept. Whether or not it was practical was secondary to the consideration that it should look practical for one hour and a half and visually impressive as well.

(Below) Some of the full-size props of the fungus vegetation inside our lunar satellite. For longer shots we used extensive minatures for the spectacular effects. Few features have ever used as many complete miniature settings with traveling matte as *The First Men in the Moon.*

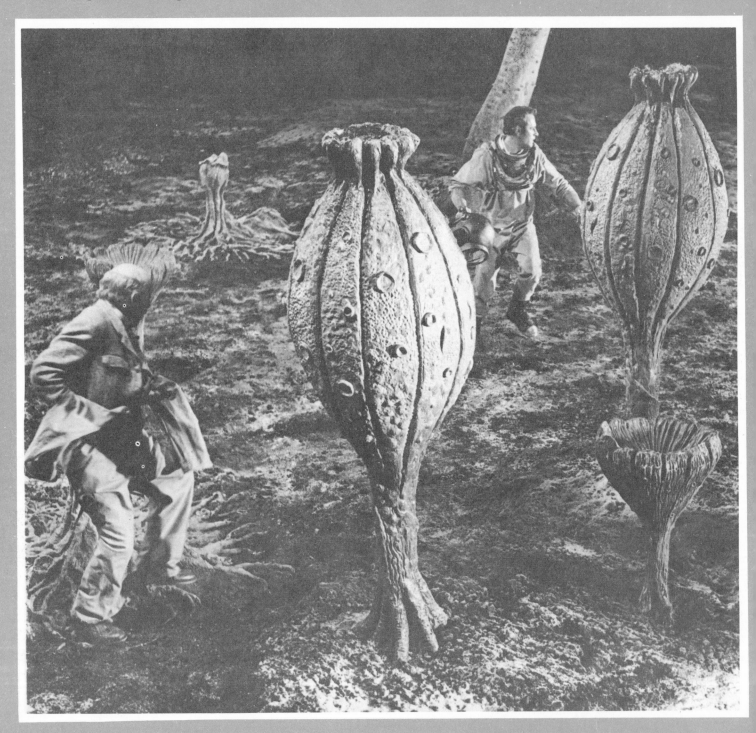

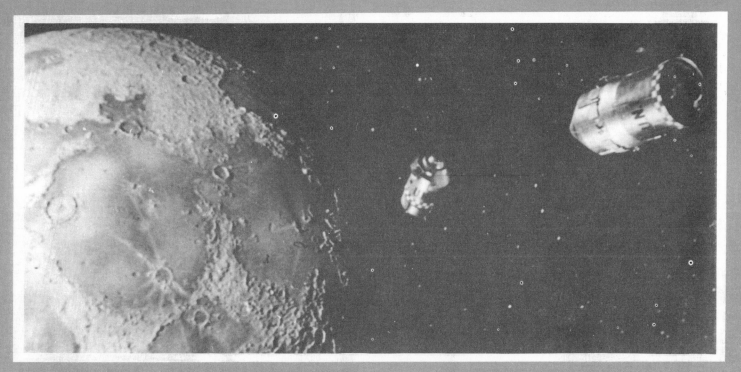

A great deal of time and research went into an attempt at an accurate staging of the separation of the landing capsule from the "mother ship." As was later described to millions of people through the medium of television, it proved to be very near the truth. I have been told that this sequence was later used on TV during one of the moon landings to demonstrate how it would look if it were possible to photograph the real separation. Miniature models and stop motion animation were used to achieve this effect.

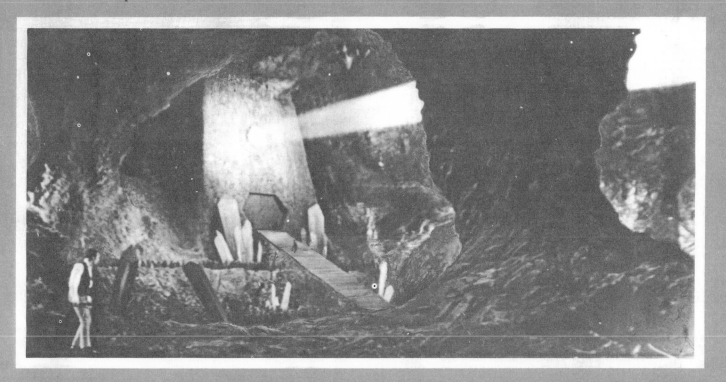

The above design was produced by using four separate pieces of film. The foreground man was inserted into the miniature setting by means of the traveling matte process, while the figure walking up the stairs in the distance was inserted by means of split screen. Another exposure was allowed for the angular ray of light.

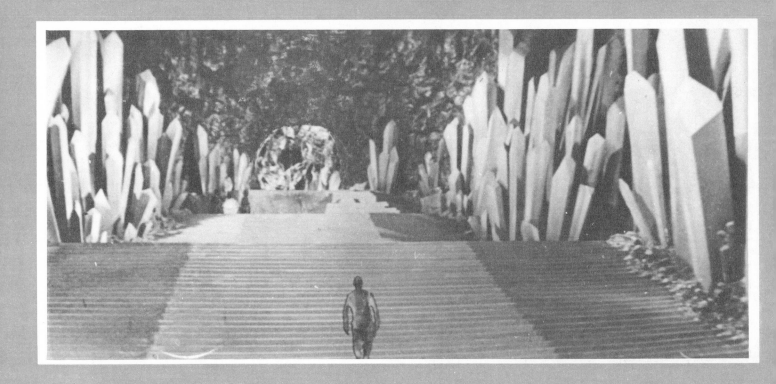

(Above) An unbalanced test of a traveling matte. In the final print, the figure in the foreground will give the impression of walking up the miniature staircase. An elaborate setting of this nature would cost far too much money if it were built to full scale. Only portions of the top of the staircase were constructed to provide a background for the dialogue sequences with the live actors.

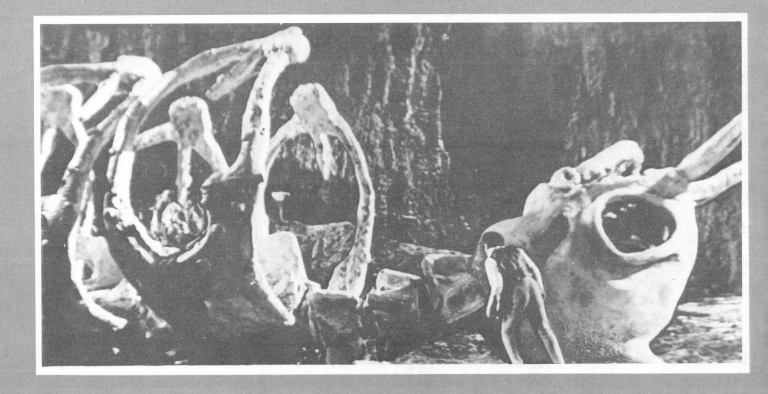

A double traveling matte was used to produce the above effect. Live-action on the background prevented the set-up from becoming a full miniature. As it is, the skeleton of the "mooncalf" was only about one foot long, thus once again saving the cost of full-size construction for just one or two shots. In color, of course, the effect is much more interesting.

(Left) A test still of the miniature central subterranean "Moon-City." The ray of light striking the monolith was double printed into the scene for the final shot. Lionel Jeffries (Cavor) was also inserted by means of split screen as he climbed the grand staircase leading to the hexagonal door of the Grand Lunar's palace.

(Right) The only reason I included this discarded sketch of an early concept of the underground "Moon City" was to give an indication as to how the modified miniature would look in a more completed form.

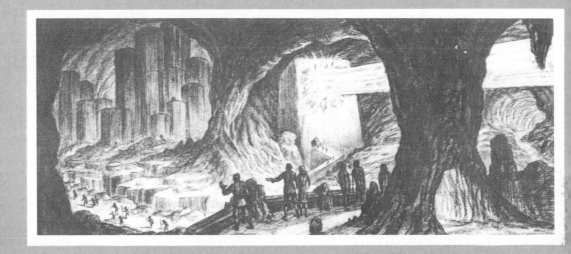

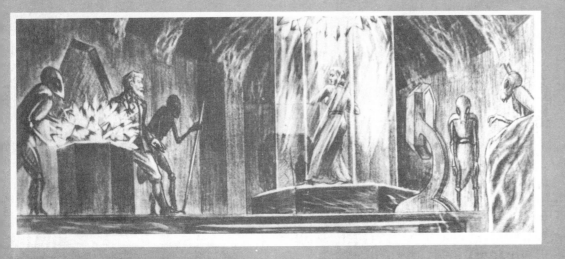

(Left) An early idea of the "speaking-chamber" in which the ant creatures try to communicate with the humans through their crystal translating device.

(Right) An early rough sketch of the "Space-Sphere" in Cavor's greenhouse. The greenhouse made an ideal setting for the building of the Sphere, particularly for its take off. The temperature control and the crashing through the roof added to the dramatic value of the take-off from the planet Earth.

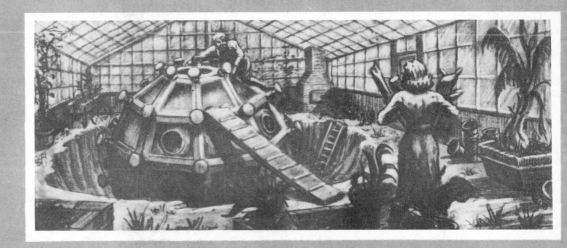

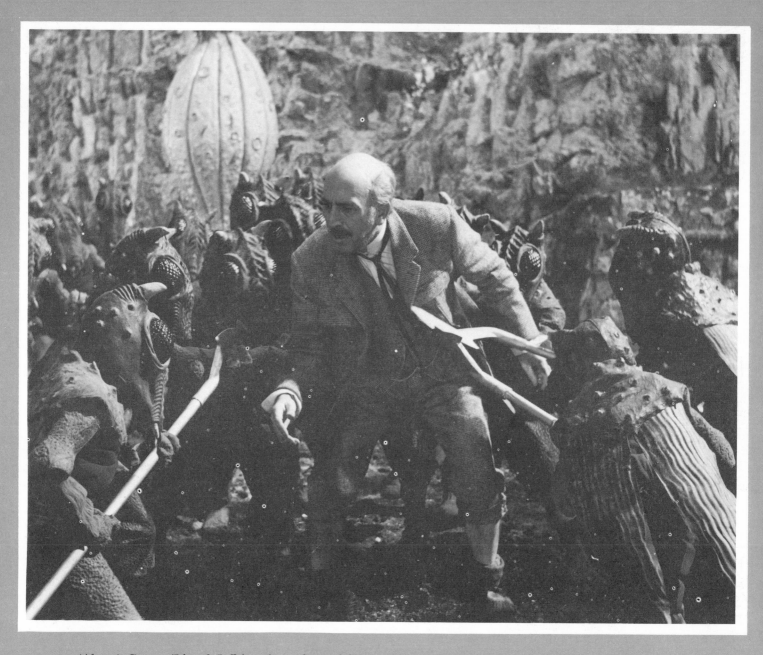

(Above) Cavor (Lionel Jeffries) is confronted by a group of "Soldier Selenites" inside the moon.

The imaginative H. G. Wells story has always been a favorite of mine. I had wanted to make a film of it for many years. Every time I mentioned it to Charles he would always bring up the argument, and rightly so, that there was not enough variety in it as it stood for a feature production. Also, space science had advanced to such a degree that it would be difficult to make it believable for today's audience. One day, while Charles was talking to writer Nigel Kneale, who is also an H. G. Wells enthusiast, Nigel came up with a brilliant idea that stimulated Charles into new interest in the project. Anyone who has seen *The First Men in the Moon* will agree that the prologue makes the whole thing work in a believable fashion. It created the possibility for us to keep the charm of the period as well as to modernize the story for acceptance by a contemporary audience. Briefly, the Prologue: In the present, and at the cost of millions of dollars, a United Nations spaceship makes the "first" man landing on the moon. During the astronauts' explorations, they come across a British flag together with a signed receipt of unmistakable Victorian date. This discovery is transmitted back to U.N. headquarters and a search party is sent out in England to try to locate the person who signed the receipt. This leads us to an elderly gentleman (Bedford) who has retired to a rest home. No one has ever believed his story that in 1899 he and two others actually made the first trip to the moon in a homemade Space-Sphere. Needless to say, he was thought to be more than a little mad. From then on we ease back to the period and use Wells's story almost intact. Nathan Juran, who had worked with us on *Sinbad* and *Twenty Million Miles to Earth* was at his best as a director here, I believe.

One Million Years B.C.

(Bottom) The Triceratops versus the Ceratosaurus took the place of the alligator-iguana fight in the original 1935 version. The difference between using animated models against enlarged lizards for the purpose of staging a prehistoric battle must, to most cinemagoers, be obvious. Not only is one able to have more control over action with the use of dimensional animation but the physiognomy of the beasts can be more accurate and believable. Real lizards are basically lethargic, making it imperative to provoke them almost cruelly in order to present an effective fight. Hundreds of feet of film can be shot at high speed just to gain a few feet of usable footage. The control one has through animation is the most important factor.

(Above) The giant Archelon ischyros appears over the top of the hill, frightening the pretty maidens of the "Shell-Tribe." In the early stages of our discussions about the remake of *One Million Years B.C.*, Michael Carreras, Don Chaffey, and I had many meetings as to how we would approach the 1966 version. While Michael reconstructed the screenplay I went back to my drawing board, attempting to devise new animals and different situations involving them. The Archelon had never been used for animation before and made a good primary foil for the Shell People. All it really wanted to do was to get back to the sea. Our intention was to save the more terrifying attackers for the end of the picture.

The Allosaurus "raiding the village" was kept almost intact, with added realism of refraining from using a man in a dinosaur suit as in the earlier version. I think all viewers will admit that the difference was enormous, not only in credibility but in dramatic impact as well. The final scene of Tumak impaling the creature on the end of a large pointed pole has always drawn gasps of awe and rounds of applause in most public showings I've attended.

(Right center) Lanzarote was a most beautifully volcanic island. Its barren and jagged landscape added greatly to the atmosphere of austere living conditions that the people of that time must have endured. The deep lava flows and irregular crevasses made perfect settings for the final eruption sequence at the end. Of course the extinct volcano cones had to be doctored with smoke pots, but the basis was there. A movie set that took two million years to build!

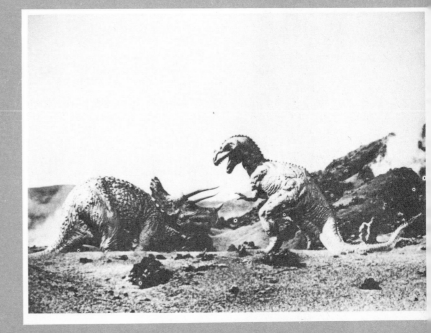

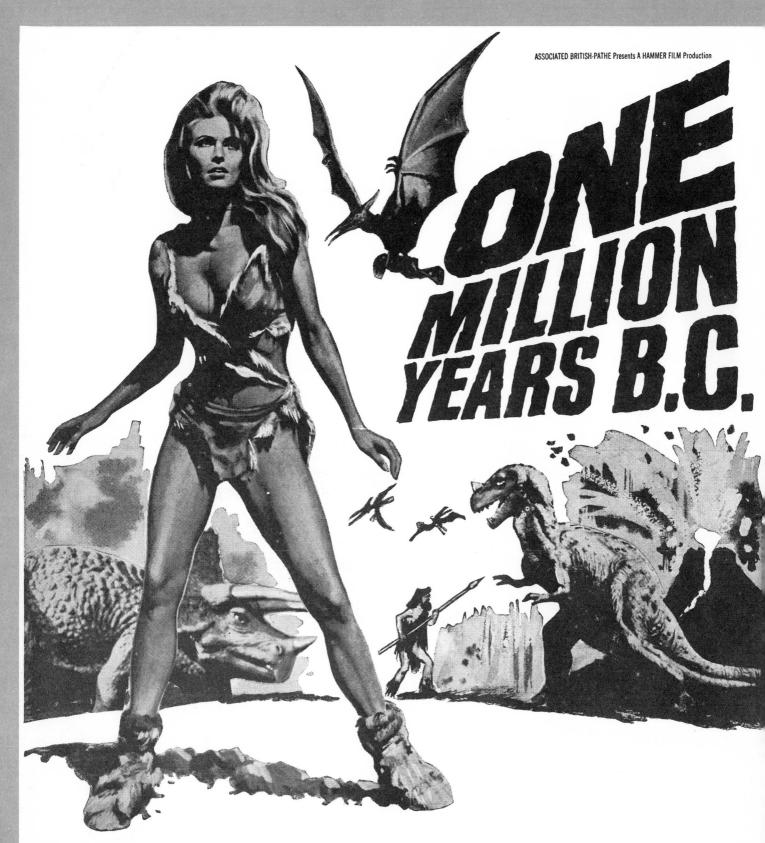

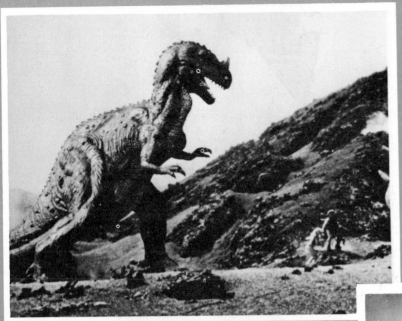

Drama and melodrama require much manipulation of fact in order to create an interesting and progressive illusion of reality. If accuracy can be supplied it is, of course, desirable. Visually, though, I feel it is far more important to create a dramatic illusion rather than be hampered by detailed accuracy simply for the sake of detailed accuracy.

The same applies to the choice of settings. Occasionally we have attracted adverse comment for not using more of a Mesozoic type landscape. I believe the only animal that might really look out of place in the stark scenery would be the Brontosaurus, a known swamp dweller. The other reptiles looked quite at home in the jagged settings we chose. Surely in the past there must have been more variety of settings than just tree ferns, jungle, and scrubland.

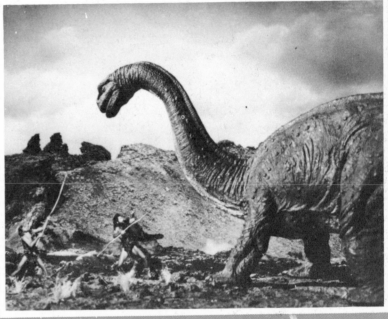

The anatomy of the dinosaurs used in *One Million Years B.C.* had to be basically correct in the light of what is known today by leading paleontologists. A great deal of research in the museums was carried out in order to give the film as much authenticity as possible. Although some of the reptiles we see together may not have lived in the same period I feel this is a minor point. New discoveries keep pushing the age of *homo sapiens* further back in time. It may yet be proven that man did live nearer the age of the great beasts than has been assumed all these years. But unless one is making a strict documentary film for the approval of scholars, these questionable "facts" are secondary to the making of a good, entertaining feature film.

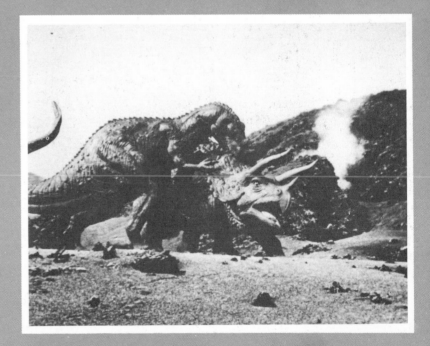

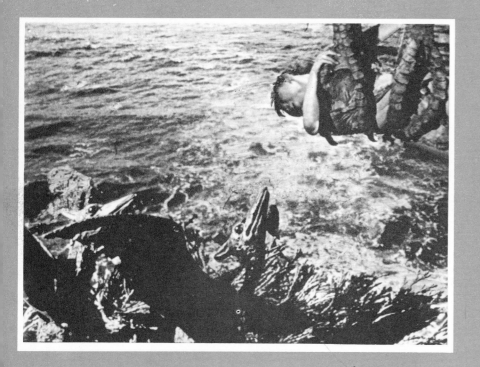

(Left) Raquel Welch, in the clutches of a giant pterodactyl, is about to be dropped into a nest of little ones. The blue backing process was employed in this shot with Miss Welch just a few feet above the stage floor.

(Left center) I have never favored using real lizards pretending to be dinosaurs, but in the re-make of *One Million Years B.C.* we felt it might add to the realism if the first creature we saw was a living specimen. I think it worked well although there has been much criticism from animation fans.

In the past I have modeled most of the creatures we use myself. Although I still construct all of the final animation figures it becomes necessary, in the interest of shortening production days, to have other people do the time-consuming modeling in clay as well as plaster molds. Based on my sketches this work is sometimes carried out by a studio sculptor; in other situations I work with sculptor Arthur Hayward who has a very artistic as well as academic knowledge of prehistoric animals.

(Below) One of the spectacular earthquake shots where the four people are buried under tons of falling rock. This was most complicated as it required split timing and the use of a composite traveling matte.

Bearing in mind the relatively small budget we had to work with, we achieved some rather striking disaster sequences, worthy of a Cecil B. DeMille epic.

Before deciding on the use of the iguana lizard we tried several different breeds. The size was particularly important. Many interesting-looking creatures had to be discarded because they were too small, thus moving far too quickly. High-speed photography, of course, slows them down, but there is a limit. The heat of the lights has a tendency to reduce their activity to a great extent and it must be remembered that to shoot over-speed requires over-lighting. This was overcome by having two animals that resembled one another.

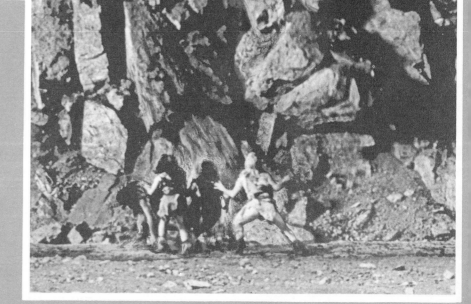

(Below) Raquel Welch and Ray Harryhausen on the island of Lanzarate discussing how Miss Welch should fall to the ground in order to be in the proper position for the Pteranodon to pick her up.

(Bottom left) The two Pterodactyls battle over the sea as John Richardson (Tumak) helplessly looks on. To animate a flying creature requires an enormous preparation of masses of overhead wires. As with the more conventional figures, the wings, head, body, and small model of Miss Welch all have to be moved progressively forward each frame of film. It was very time-consuming to have to cope with two flying figures.

(Below right) The giant Pteranodon attacks part of the Rock Tribe. In a shot like this, involving more than one person, their synchronized eyeline has to be carefully watched.

(Bottom right) The Pteranodon carries Raquel Welch to its nest.

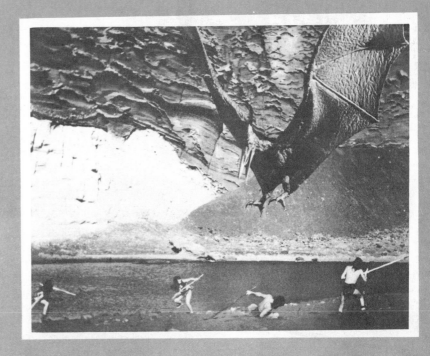

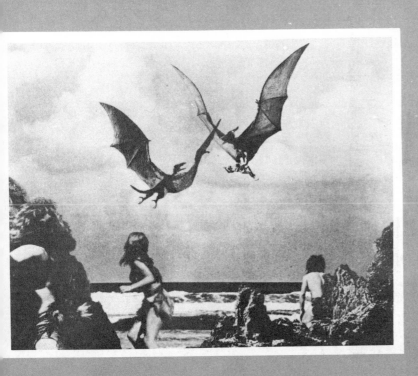

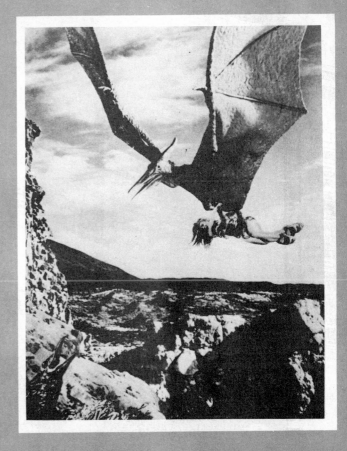

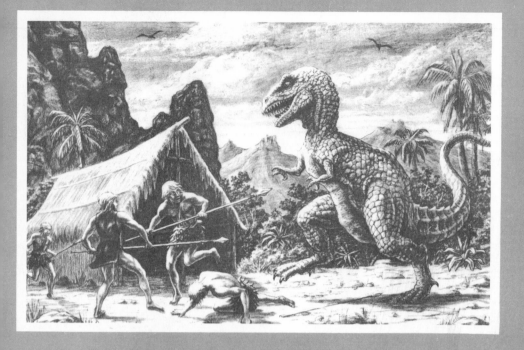

The sketches on this page are the pre-production drawings indicating some of the highlights of *One Million Years B.C.* I have often been asked about the proposed Brontosaurus sequence that was cut from the end of the film. In its place was Sakana's Invasion of Tumak's cave. It was felt, at the time, that there were more than enough animated creatures throughout the rest of the film and to keep it in would add another two to three months to the already excessive animation schedule. This was the main reason the sequence was dropped, before any complete production shooting would take place. One of the important necessities of the film business today is compromise in favor of practicality. With all of the other thrills in the production I doubt if it really was ever missed.

(Above) Four discarded rough sketches from the sequence that was never shot.

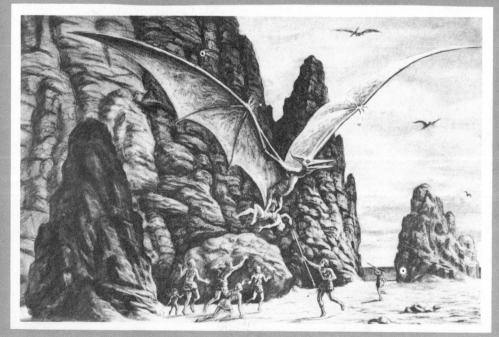

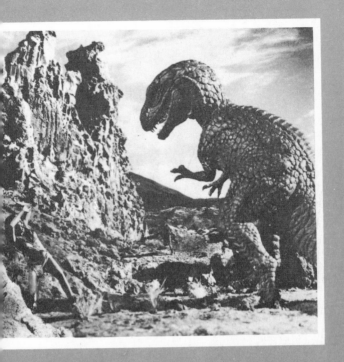

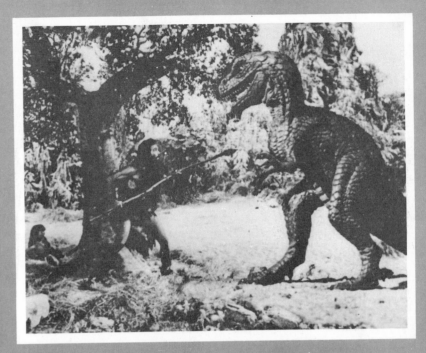

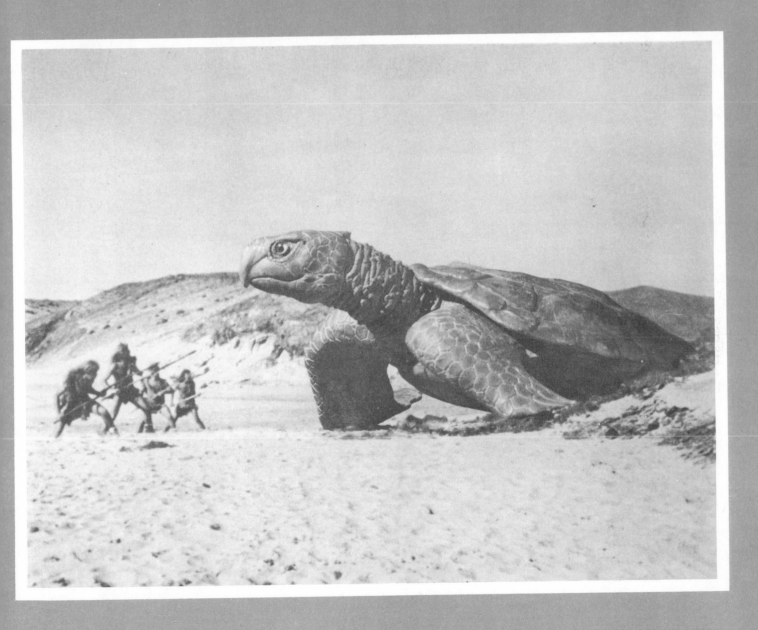

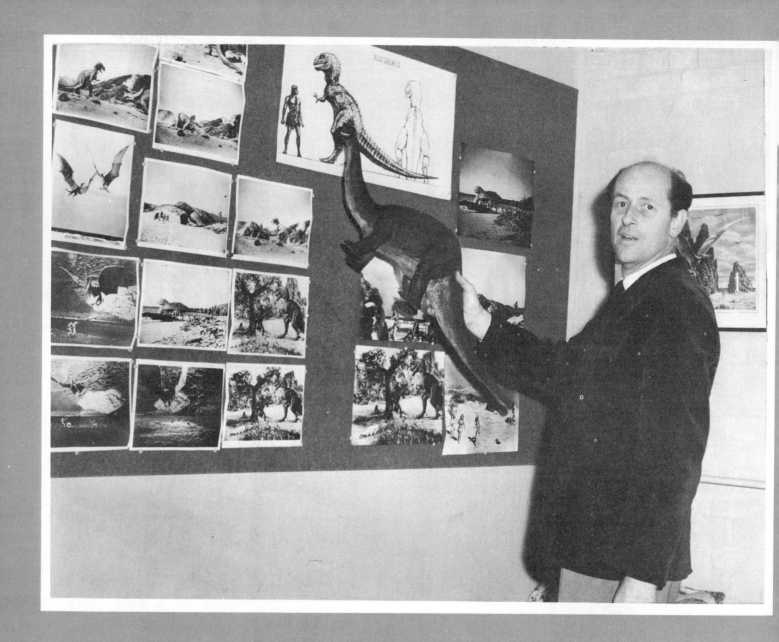

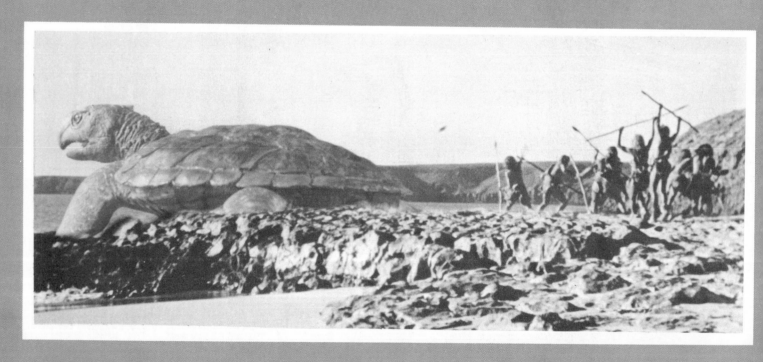

The Valley of Gwangi

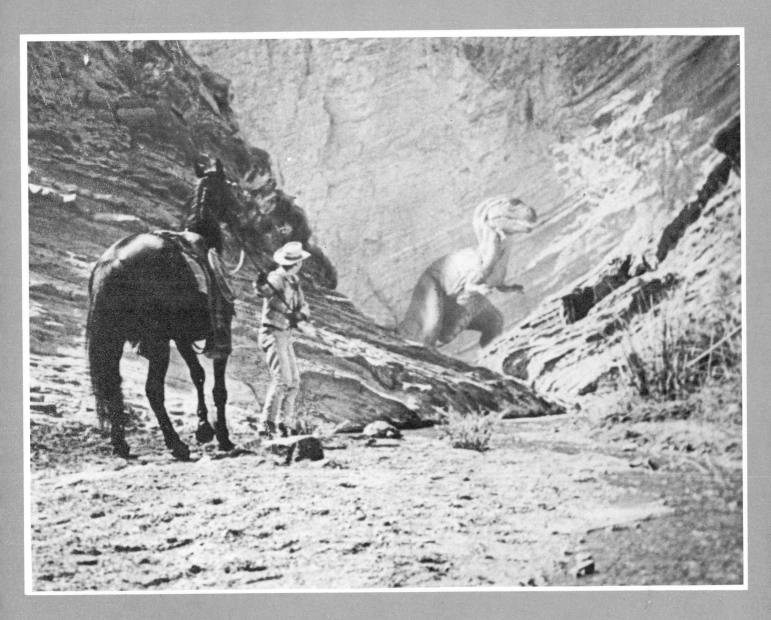

The ill-fated *Gwangi*, as it is quite well known, was originally to have been an RKO Radio Picture produced by John Speaks and Willis O'Brien. It was begun in 1942 and later abandoned after almost a year of preparation of scripts, production sketches, continuity drawings, and about five or six large glass paintings. There also exists, somewhere in Hollywood, three very large oil paintings on hardboard by O'Brien and Jack Shaw. Each basic set-up was built in miniature painted cardboard dioramas about two feet across. Even a jointed, stop-motion model of the Star was constructed. For some rather complicated reason *Gwangi* was abandoned by the front office and *Little Orphan Annie* was made in its place. All of the vast amount of preparation has long since been lost, with the exception of the original script and photographs of some continuity drawings. The disappointment to O'Brien must have been tremendous as this followed closely the disintegration of his *War Eagles* at MGM.

Although the basic idea from the original *Gwangi* script was maintained, many new situations were added to the story line. Bill Bast, Charles, and I all felt strongly that the period should take place about 1900, as modernization would simply present many *cliché* problems in disposing of Gwangi with present-day weapons.

As an evening's entertainment *The Valley of Gwangi* had a number of interesting and exciting moments for the whole family that many reviewers completely overlooked in their quest for the "bandwagon" of permissive protest pictures.

COWBOYS BATTLE MONSTERS IN THE LOST WORLD OF FORBIDDEN VALLEY.

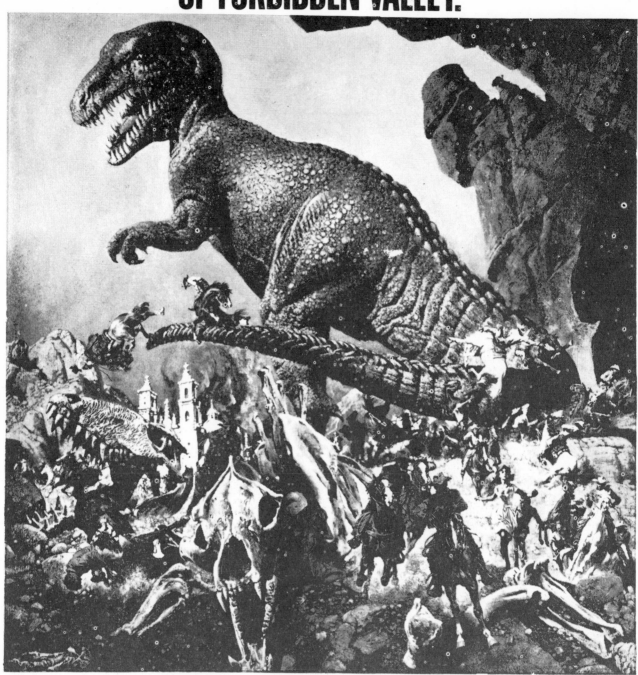

A CHARLES H. SCHNEER Production

THE VALLEY OF GWANGI

A

STARRING
JAMES FRANCISCUS · CO-STARRING **GILA GOLAN** · **RICHARD CARLSON**

ASSOCIATE PRODUCER AND CREATOR OF VISUAL EFFECTS
RAY HARRYHAUSEN

MUSIC COMPOSED AND CONDUCTED BY
Jerome Moross

SCREENPLAY BY
WILLIAM E. BAST

PRODUCED BY
CHARLES H. SCHNEER · DIRECTED BY **JAMES O'CONNOLLY** · Filmed in **DYNAMATION® TECHNICOLOR®** · A WARNER BROS.-SEVEN ARTS RELEASE through Warner-Pathe

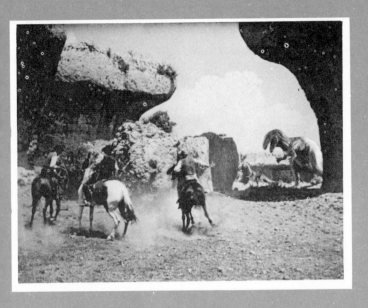

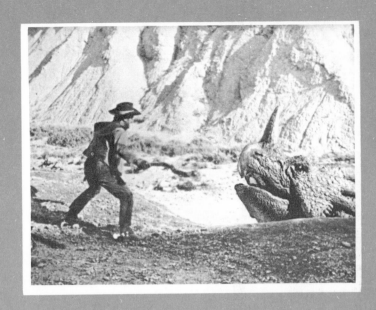

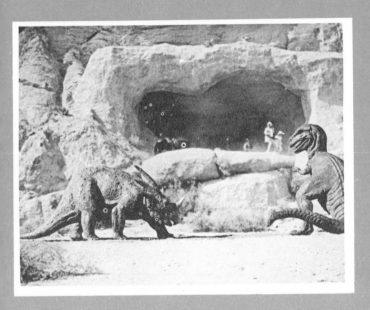

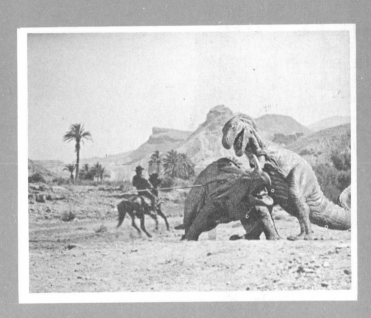

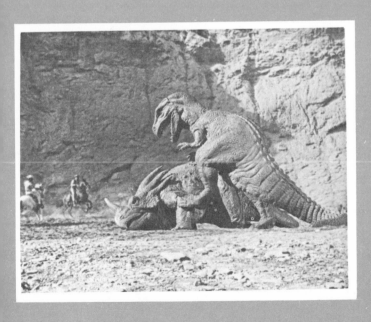

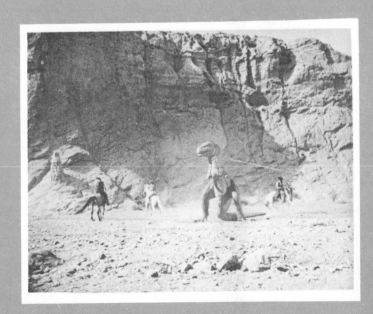

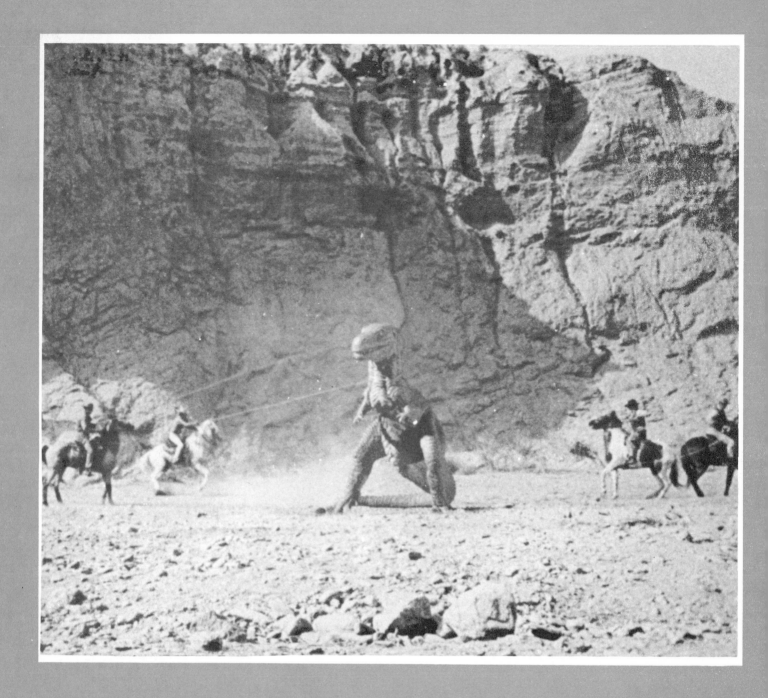

(Above) The scene where Gwangi is being roped by cowboys was really the highlight of the film. It isn't every day that one can see a group of cowhands attempt to rope a dinosaur. This one sequence had implanted itself in my mind for years since the day in 1942 when I first saw Willis O'Brien's original sketches for the proposed production. On re-reading the old script in 1966, Charles and I felt it still had great production values for an action film. It took months of tracing the owners of the property, who had purchased it from the old RKO assets when the studio closed. The pity is that it should have been made about three years earlier, as by the time we finished the production in 1968 the public taste seemed already to have turned to that frightfully "new" vogue—Sex and Revolution.

The roping sequence took over five months before the animation camera. Time and patience were necessary to control the intricacies of matching the ropes to the riders as well as the many shots of bodily contact to the live-action. During shooting, a jeep with a 15-foot pole attached to it was used for *Gwangi*. This was later blotted out by more "hocus-pocus." I will not go into the details of how this was achieved as the "magician" must keep a few tricks to himself.

(Right) Gila Golan and Ray Harryhausen.

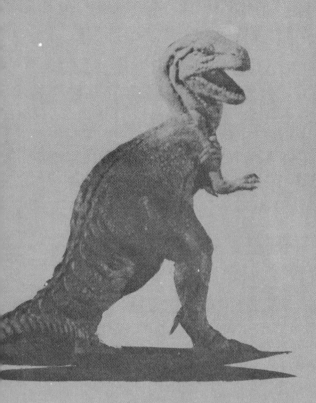

(Right) For the Pterodactyl sequence we constructed a full-size model for the close shots of the cowboy wrenching the neck of the giant bird. These were used only occasionally because the most effective angles were the medium and long shots where we see the complete wing span. In the distant angles it was necessary to use an animated creature with the real man included through composite photography. Unfortunately I do not have a photograph to demonstrate its effectiveness over the full-size model.

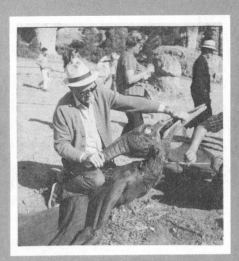

(Below) The Arena shots were photographed in the central bull ring of Almeria while the interior and exterior background plates of the Cathedral sequence were recorded in the town of Cuenca, about a two-and-a-half hour drive outside of Madrid.

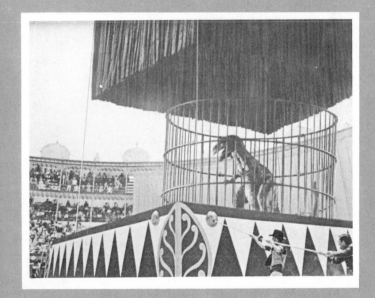

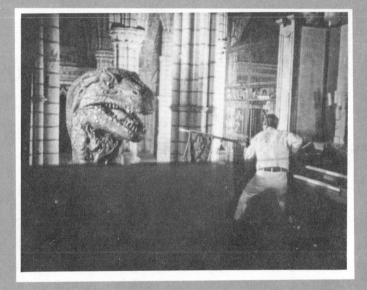

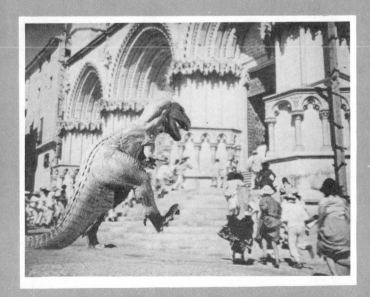

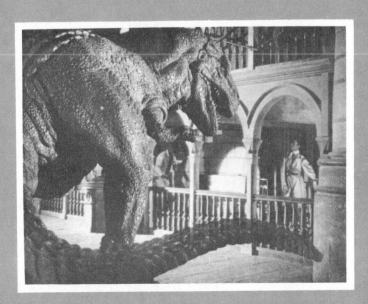

(Left) The Eohippus was part of the original story, only it was not used in the same context. It was a sequence I dreaded doing for several months and kept postponing it until last. It was done in great haste and turned out to contain some of the smoothest and most natural animation in the picture.

(Right) The scene where the pterodactyl plucks a man from a running horse was very time-consuming inasmuch as each frame of the animated bird had to give the illusion of actual contact with the live boy on the horse. As one might guess, a large crane was employed to fly the boy into the air by means of an invisible wire.

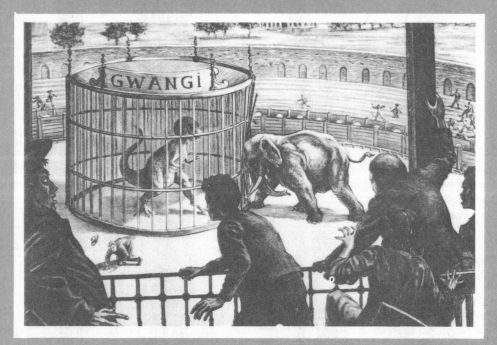

(Left) The elephant battle was another addition to the story. Unfortunately, we were unable to hire an 11-foot pachyderm in Spain, which forced me to animate the model in scenes where I did not plan to nor want to. In the end result it was far better action than one could obtain with a real animal.

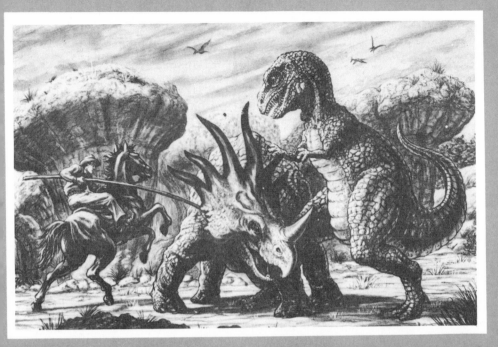

(Left) Gwangi fighting a Styracosaurus. In the original 1942 script he was in combat with a Triceratops.

(Bottom) Gwangi defies three cowboys. The timing of a scene such as this requires the utmost precision in eyelines and positions.

The choice of stories we elected to film are not always to everybody's taste, particularly among the film reviewers. But it must be admitted that all our subjects are imaginative, usually exciting, and mostly interesting to anyone who has not closed his mind to the appreciation of the "wondrous."

The many fascinating forms of entertainment we have today need not all preach "revolution," "permissiveness," "social arguments," or the fad of the moment in order to be considered worthwhile. Stimulating the audience to take note of certain injustices and social problems is naturally important in a visual medium as well as in a literary field. But relaxation, some escapism, and excursions into the world of the child's imagination is as necessary for a rounded point of view as the constant bombardment of propaganda with which different groups try to "brainwash" the public into thinking the way they want them to think. Let us try to keep the field of the cinema of the future balanced, like it was and always should be—a variety—an omnibus—something for everyone and for every mood.

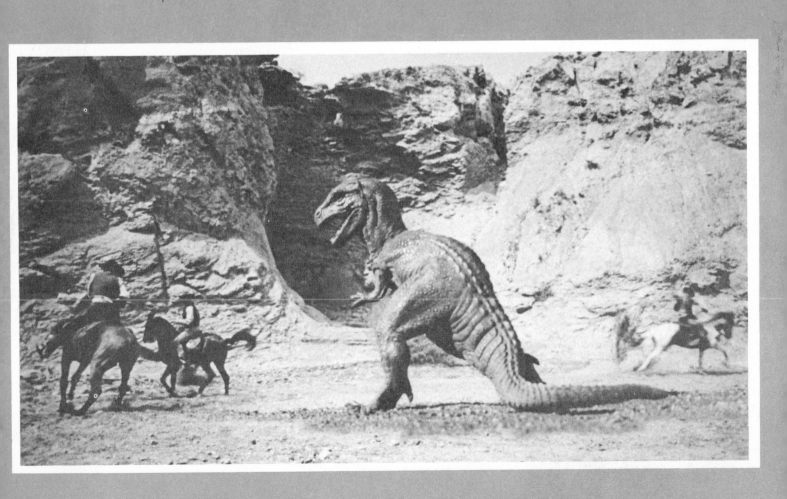

(Above) James Franciscus in the Cuenca Cathedral with arch-villain Gwangi.
(Right) Although this photo was not taken at the proper angle, it demonstrates the use of a top miniature that saved the construction of a full-size balloon. At the proper angle the balloon will appear to be connected with the box-like curtain on the top of the rear platform.

In Conclusion

While we use all the "Tricks of the Trade" and more, I hope it is clear that at no time do we use these effects merely for the sake of presenting "tricks." Most of our subject matter and my style of staging were the direct result of choosing a type of story that could not be photographed with conventional techniques. Therefore, to put such stories on the screen, most of which were designed for pure exciting entertainment, it was necessary to resort to these various special techniques.

Three dimensional animation, in any language, must be an art: a creation of something out of nothing; a projection for an hour and a half of pseudo-reality of the most bizarre stretches of the imagination—the injection of the illusion of life into the basically inanimate.

Walt Disney, along with others, developed the cartoon technique to the ultimate degree. Although the cartoon came into existence about the same time it became more popular than dimensional animation because it could be massed-produced by many people. A cartoon animator need only draw the extremes of action and then hand over his work to an assistant to fill in the "in-betweens." His assistant would then turn over the drawings to the inking and painting department, which in turn places the final product into still other hands, the photographic section. During this process many tests of action are made for refinement. This assembly line method (and I do not imply any derogatory meaning whatsoever) is very difficult to employ with dimensional stop-motion. It has been tried but found costly and time-consuming to the point of destroying its commercial possibilities. Dimensional animation has almost always been the product and imagination of one or two men who see the project through to its completion. Willis O'Brien was the first to develop this unusual means of expression into a commercial venture as far back in film history as 1925 with his *Lost World.* Few others have followed in his footsteps. I consider it most fortunate that in 1933, after seeing O'Brien's masterpiece, some compelling force guided my future into what is surely one of the most unusual professions in the world.

Dimensional animation should not and cannot compete with the drawn animated cartoon. It demands its own type of story and more personal means of execution. Many patterns of the past have been repeated with variations. Perhaps there are some new ones to come; it remains to be seen. But in general the film-going public knows little about the complex creative process that must go on behind the scenes in order to make up a few short hours of imaginative entertainment. I make these points not to try to glorify mine or the past efforts of others in this field, but to contribute in some way a more general appreciation of what may come from this medium in the future.